TATTOO
DESIGN DIRECTORY

Vince Hemingson

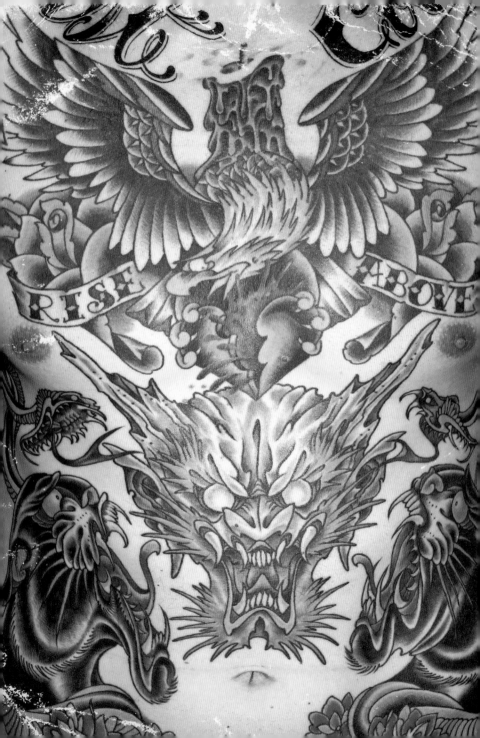

TATTOO

DESIGN DIRECTORY

THE ESSENTIAL REFERENCE FOR BODY ART

VINCE HEMINGSON

CHARTWELL
BOOKS, INC.

This edition published in 2009 by Chartwell Books, Inc.
a division of Book Sales Inc.
276 Fifth Avenue Suite 206
New York 10001
USA

ISBN 10: 0-7858-2489-8
ISBN 13: 978-0-7858-2489-3

QTT.TATD

A Quintet book

This book was conceived and produced by
Quintet Publishing Limited
The Old Brewery
6 Blundell Street
London N7 9BH
United Kingdom

Project Editor: Asha Savjani
Art Director: Michael Charles
Designer: Emma Wicks
Illustrators: J. D. Crowe, Bernard Chau, Jane Laurie,
 Ben Mounsey, and Damion Mulrain
Design Assistant: Jane Laurie
Managing Editor: Donna Gregory
Publisher: James Tavendale

Printed in China by Midas Printing International Ltd

coɳтɛɳтs

FOREWORD

I first laid eyes on Vince Hemingson in Samoa. It was the fall of 1999. I was there with my friend, photographer Bernard Clark, covering Paulo Sulu'ape's unforgettable and historic Tattoo Millennium Convention on the island of Upolu. The event was held to commemorate the day, a thousand years ago, when twin sisters, Tilafaima and Taima, swam all the way from Fiji, bringing their hand-wrought tattoo tools—the *au*, the *sausau*—to the beach at Faleaséela. To celebrate this glorious moment in Samoan history, Paulo invited several of the world's most prestigious and learned tattoo artists to a convention and party. The seventy or so participants came from Denmark, The Netherlands, New Zealand, England, Germany, Canada and the United States. Because of the incessant heat and humidity, all of us, including the women, wore traditional, thin cotton lava-lavas around their waists. Most of the men went shirtless or sported sweat-soaked tank tops. We were a very scruffy bunch. Lots of threadbare sandals and rubber flip-flops. The ladies wore sun-bleached halters and fanned themselves with magazines.

And that's when I saw Hemingson. I had never met him before, so when he stepped from the thick, green jungle foliage like a matinée idol—hair slicked back, perfectly groomed mustache and goatee—marching toward us like a man on a mission, I was more than intrigued. I remember that, while the rest of us looked like castaways, Hemingson wore a perfectly matched Bermuda short and a khaki shirt ensemble—emblazoned with, I might add, a bright-red, hand-stitched logo centered neatly above the breast pocket. He reminded me of Jon Hall in the T.V. series *Ramar of the Jungle*. Yes, there he was, Mr. Vanishing Tattoo himself, Vince Hemingson.

If memory serves me right, Vince had just arrived from a scouting party in another remote location—Borneo I think—where he was gathering info for a National Geographic television series. It was all part of his research, gathering cultural information about tribal tattoo customs that were, because

of the inevitable march of time, quite simply disappearing. Samoa, because of its long tattoo history, was perfect for one of Vince's episodes. That's why he came to Apia.

But Vince did more than look the part. He spent more than a decade searching and researching every aspect of this extensive and fascinating subject. Not only did he get his show aired by National Geographic (and won a mantel full of awards doing it), Vince also created the world's top-rated tattoo website, hosting over a million viewers a month. Yes, vanishingtattoo.com is both the industry's premiere website and a tribute to Vince's absolute dedication, skill and perseverance. And it all exists thanks to a love so passionate that it has given birth to the very volume you hold in your hand, *Tattoo Design Directory*.

Yet, *Tattoo Design Directory* is more than an alphabetical listing of names and dates. It is a compendium of just about anything anyone wants or has a right to know about tattooing. It's a fireside reference. A terrific beach read. A browser's dream. There are images galore, boatloads of ideas and definitions and, for the historians in the crowd,

lots of background material and surprising, little-known facts. There are literally hundreds and hundreds of entries. And the book is perfect for newbies, those who are thinking about getting their first ink. Long-time enthusiasts will love it, too. In fact, every tattoo emporium should have a copy of this delightful, handy-dandy reference manual, if for no other reason than to hand it to anyone who asks one of those infinite, all-encompassing questions that come up right in the middle of trying to tattoo a client.

So, there you have it. A fabulous new book to add to your tattoo library. Hooray to the publishers for publishing it. Hooray to Vince Hemingson for putting his heart and soul into this entertaining and all-encompassing volume. And, lest we forget: Hooray, Ramar of the Jungle!

Bob Baxter, Editor-in-Chief
SKIN&INK Magazine

introduction

As with most cultural practices and artistic styles and trends, tattoos and tattooing have weathered various cycles of popularity, waxing and waning over the years, but never disappearing.

Tattooing was widely practiced by many cultures in the ancient world, and was associated with a high level of artistic endeavor. The imagery of ancient tattooing is very similar to that of modern tattooing, and throughout history tattooing, like other forms of body decoration, has been related to the sensual, erotic, and emotional aspects of the psyche. While tattoos have traditionally been part of an elaborate rite of passage within a specific culture, they have also served as marks of royalty and rank; symbols of spiritual and religious devotion; marks of bravery and prowess in battle; sexual lures; pledges of love; punishments; amulets and talismans for protection; and as the marks of slaves, outcasts, and criminals.

Tattoos can take the form of simple symbols or intricate designs, and many are potent with meaning. The tattoos of the ancient Chimu of Peru in South America, and those of the diverse ethnic tribes of the island of Borneo in the South China Sea, are characterized by bold abstract patterns, while those of the Haida of the Pacific Northwest of North America feature fantastic mythological animals. Animals are a frequent subject of tattoos, and all manner of creatures and denizens of the natural world are represented on the human canvas. In many cultures, tattoos are traditionally associated with magic, totems, and the desire of the tattooed person to become identified with the spirit of a particular animal.

RITES OF PASSAGE

The most popular tattooing genre in the world today is that of the tribal tattoo. Modern tribal tattoos are largely inspired by the traditional tattoos of the indigenous peoples of Borneo and Indonesia, the South

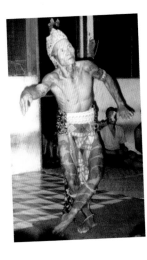

An elder from the Iban tribe of Borneo performs a dance for his longhouse

between adolescence and adulthood. The tattoo designs themselves were symbols that had important meaning within each community, tribal group, and culture. Tribal tattoos often used symbols of animal and spirit totems, and they are just as popular today with individuals in the west as they were with the original Haida, the Iban of Borneo, and Polynesian peoples.

Used as a rite of passage, there are clear distinctions and differences between the genders when it comes to body art. Young women are often tattooed with marks that the culture identifies as beauty marks, and that celebrate fertility (see page 53). The tattoos themselves are frequently focused on the erogenous zones, such as the thighs, buttocks, abdomen, and breasts. Unlike their female counterparts, where the line between childhood and womanhood is clearly biologically defined, it is often more difficult for a culture to pinpoint exactly when boys become men. The use of tattooing as part of a bloody, painful, and memorable ceremony offers an inspired solution. The initiation ceremony that serves as the rite of passage for young men not only

Pacific and the Pacific Northwest of North America. These bold, graphic designs inspired the fascination of Captain James Cook and his men in the eighteenth century, initiating a revival of tattooing in Western Europe, and they are no less influential today.

Tribal tattoos once marked individuals, both male and female, as members of a greater community, and were traditionally part of a larger, more elaborate rite of passage

inculcates them with the virtues and values that the community celebrates in its male members—the courage and strength to withstand pain and suffering with stoicism, an indication that they will protect their community as able warriors—but the tattoos also clearly identify all the male members of the community who are considered adult men. In cultures that embrace body art, the identification of the position of individuals within the community is a problem easily solved with tattoos.

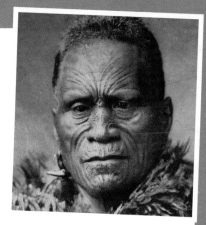

Tāwhiao, leader of the Waikato tribes and second Māori King, c.1894

Within modern urban cultures, where the line between adolescence and adulthood is increasingly blurred, and where young people do not usually have specific rites of passage, many take matters into their own hands. It is common for peer groups of young men and women, whether they be close friends, school mates, members of athletic teams, or fraternal or community groups, to adorn themselves with body art that celebrates their sense of shared experience. In many instances they choose to get tattooed with the same design or symbol.

MARKS OF RANK

Before the advent of modern technology and the invention of the first modern electric tattoo machine in 1892, it must be remembered that all tattooing, in both traditional and modern cultures, was done by hand. Traditional tattooing using hand implements was often a time-consuming process, and one that was usually expensive. The more you were tattooed, the greater the symbol of personal wealth. Among traditional cultures like the Māori of New Zealand, tattoos often told specific genealogical information about an individual. A man or woman's tattoo could not only identify their paternal and

maternal lineage but, because Māori *tā moko* was an ongoing practice, it also often revealed an individual's political, social, and military rank.

Among the Iban people of Borneo, tremendous status was accrued by a warrior according to the number of human heads he had collected. This record was carefully documented by tattoos on the hands. Other Iban tattoos told the story of a man's accomplishments throughout his life, and a heavily tattooed individual had greater rank and status within the community. Indeed, it was important for the Iban to become heavily tattooed because they believed that tattoos illuminated their way in the darkness of the spirit world of the afterlife.

Unlike modern Western tattooing, where the choice to get tattooed is that of the individual, and the decision of which tattoo to get is a matter of personal taste, tattoos that denote individual rank within a larger community are almost always acts that require the consensus of the decision-making apparatus or executive of that community. Tattoos of rank are badges of honor and status handed out by groups of grateful and approving peers.

SYMBOLS OF RELIGIOUS DEVOTION

Throughout history people have used tattoos to identify their religious affiliation and to signal their devotion to their spiritual beliefs. Berber women in North Africa have tattooed symbols of their faith on their faces and arms for centuries. Religious devotees on a pilgrimage, regardless of faith, often got tattoos to commemorate their journey. Today, religious images such as crosses, angels, doves, and other icons, are among the world's most popular tattoo designs.

Coptic Christian crosses are often seen on women in the Lalibela area, Northern Ethiopia, to honor their religious beliefs

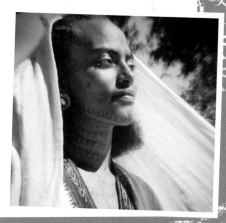

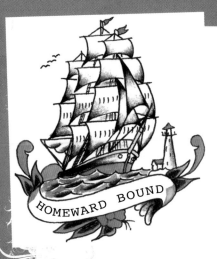

'Homeward Bound' design by Buddy Mott, 1950s

MARKS OF BRAVERY

Few tattoo traditions have a longer or more storied past than military tattoos. Tattooing is a revered martial tradition and body art has long been the mark of a true warrior in the eyes of many. For the past two centuries in the West, and for many millennia before that all around the world, men in the military services have traditionally used very specific tattoo designs to proclaim their membership of a branch of the armed services and as an overt sign of their patriotism and national fervor.

Military tattoo designs for men of arms may feature the actual insignia of a particular military unit, the flags of their nation, or designs that symbolize their military branch. At the turn of the twentieth century it was estimated that over 90 percent of members of the British Admiralty, or Navy, were tattooed, with tattoo designs ranging from anchors and mermaids to actual images of the ships those sailors served on.

Many other endeavors and careers that call for overt and conscious acts of courage, and where an individual may be at personal risk of harm, also routinely celebrate those virtues and character traits with tattoos.

SEXUAL LURES

There has always been an erotically charged aura around tattoos, due in no small part to their reputation during most of the twentieth century for being just a little bit racy. In modern times tattoos have been seen as belonging to the realm of "bad boys and naughty girls," while in traditional cultures tattoos were often used to indicate that a woman had reached the age of sexual maturity and was in the market for a husband. A tattooed member of a community was recognized

as an adult, with an adult's sexual needs, wants, and desires.

If power really is the ultimate aphrodisiac, tattoos that indicated an individual's high social rank and status would have only helped make a person more attractive to the opposite sex. Some cultural anthropologists also theorize that the ability to withstand a large amount of tattooing without any ill effects may serve as an indicator of the health and quality of an individual's immune system. The tattoos may then serve as a signal that a person has good genes.

In a more modern context, men and women have chosen gender-specific tattoo designs to accentuate and draw attention to their best masculine and feminine attributes. Men get tattoos that exaggerate their physiques, drawing attention to their upper bodies, in particular their shoulders and arms. Men also tend to choose tattoos that are overtly masculine, or perceived to be "tough," with an emphasis on powerful animals and other iconic symbols of strength and virility. Male body art is also likely to be much more extensive than female body art, with both greater and

Tattoos are often used to draw attention to an individual's most alluring features, emphasizing a woman's curves or a man's physical strength

denser coverage. Women often choose more feminine designs, with butterflies and flowers by far the most popular choices. They also choose to display them in visually powerful erogenous zones; the most common places being the lower back, hips, bikini line, and breasts. In other words, a woman's tattoo draws the eye to her most powerful sexual flags—her curves. It is also no accident that many women choose to position tattoos where they can be casually displayed or strategically covered up. Few things are as tempting or as teasing as the tip of a tattoo peaking from a hidden spot. For both men and women, tattoos say "Look at me!"

A PLEDGE OF LOVE

The single greatest reason for regretting a tattoo is because it contains the name or initials of a former lover or significant other. And yet, hearts and flowers with declarations of love continue to pay the rent for tattoo artists: In the first instance when the tattoo "I love Mary" is inked in a scroll beneath a red rose, and in the second instance when the client returns to have the name covered up with some artfully inked leaves.

However, there are also many pledges of love that people do not regret. Interestingly, it was soldiers going to war who popularized the heart tattoo, inscribed with the familiar "I love Mom," as pledges of love for families and sweethearts left behind. These tattoos served as reminders for homesick soldiers or sailors of why they were at war and for whom they were fighting, and prompted reminiscences of the life

A horseshoe tattoo is said to bring good luck

left behind and the hearth fires burning at home.

The memorial tattoo, commemorating a lost love, child, or family member, or a friend who has passed away, is another example of the tattoo as a pledge of love. Members of the armed services, police officers, and firefighters may use this tattoo to memorialize a fallen comrade, and such tattoos allow people to grieve the loss of a loved one and honor their memory as they try to get on with their own lives.

PROTECTION

Tattoos have for centuries acted as talismans and amulets of protection, for surely one of the things that set us apart from the other primates is our profound belief in superstition. Almost all cultures that practice

The heart is a universal symbol of the feminine, often used as an expression of romantic love

Inner lip tattoos originated as an identifier used in managing wildlife and livestock

tattooing have incorporated into their design philosophy a belief that certain tattoo symbols will protect the wearer against harm or bring them good fortune. Many cultures believe their tattoos will turn away evil spirits; cure or prevent snake and other poisonous bites; deter attacks from predators; and act as shields for knives, spears, and even bullets. Such tattoos are worn to inspire confidence and diminish worry and doubt about all the vagaries that plague human existence.

Even today, popular tattoo designs incorporate four-leaf clovers, horseshoes, and a long list of religious and spiritual symbols meant to appease the gods and ensure divine protection for the true believer.

PUNISHMENT

No account of history would be complete without some reference to the darker side of human nature. Down through history tattoos have been used, sometimes with force, against an individual as a form of punishment. In Roman times, slaves were often marked with tattoos, as were prisoners of war and criminals. In Japan, criminals were at one time tattooed on the forehead, with the nature of their crimes clearly spelled out for all to see. During World War II, Nazi atrocities came to be exemplified with the forced tattooing of Jewish prisoners in concentration camps. Even today, within prisons around the world, a culture and language of symbols has sprung up among criminal populations, with tattoo designs taking on very specific meanings.

BODY ART TECHNIQUES

The decision to get a tattoo, and equally which design to choose, should not be made lightly. Arm yourself with all the facts in order to ensure you make the right choice.

THE NATURE OF THE TATTOO

One online medical dictionary defines the tattoo as "the permanent insertion of ink or other pigments below the skin using a sharp instrument." Sadly, it then goes on to describe tattoos in the Western world as traditionally being historical signs of criminality and shame. Merriam-Webster's dictionary gives a similar definition, stating that a tattoo is "an indelible mark or figure fixed upon the body by insertion of pigment under the skin," and graciously declines to either editorialize or pass moral judgment.

TATTOOS AND THE SKIN

Human skin is a complex structure that consists of three principle layers: the epidermis, or epidermal layer; the dermis, or dermal layer; and a subcutaneous structure called the hypodermis, which attaches the skin to your muscles and skeletal structure. The outermost layer of the epidermis consists of dead cells, and a healthy body completely replaces this layer every month—a remarkable feat when you consider that the average adult has 20 sq ft (1.85 m^2) of skin.

So why don't tattoos disappear every month? The tattoo remains permanent because, done correctly, the pigment particles are introduced underneath the epidermis and into the skin strata between the epidermal and dermal layers. The dermal layer contains numerous blood vessels, nerves, hair follicles, and lymphatic vessels, and the tattoo pigments lie trapped in the dermis.

Tattoo pigments are foreign objects and, if it could, your body would eject those pigment particles in a heartbeat. In fact, within moments of a tattoo needle penetrating the skin, your body is readying its defenses. A tattoo is a wound and the presence

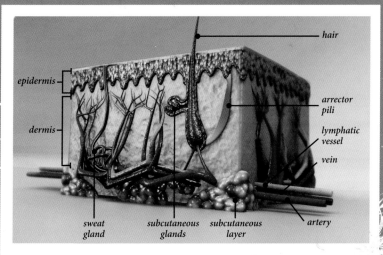

Human skin is a complex structure that consists of three principle layers: the epidermis, the dermis, and a subcutaneous structure called the hypodermis

of foreign material immediately rallies your lymphocytes—or white blood cells—to the scene of the injury. The lymphocytes will remove any pigment particle that is small enough, but your body has to adopt a different strategy for any pigment "boulders" that the lymphocyte bulldozers can't move. When faced with particles too big to remove, macrophages, which are another form of white blood cell, encircle the particle and devour it. However, if the pigment particle is inorganic and nontoxic, the macrophage will begin a process that results in the formation of scar tissue around the particle, walling it off and anchoring it in place. And there it will remain, indelible and permanent. However, if your body's defenses determine that the particle is organic or toxic, it will result in either an infection or an attempt to reject the particle from the body to prevent further damage.

tattoo inks

Tattoo inks, like house paint, consist of pigment particles suspended in a carrier solution. The vast majority of modern tattoo pigments are inert metal salts or oxides.

Traditionally, carbon-based tattoo inks make up most tattooing pigments; the fine soot from burnt animal fats being particularly favored. Carbon-based blacks are among the smallest pigment particles, while whites made from titanium oxide are among the largest. Carrier agents are used to keep pigment particles in solution and allow a fluid application. In the case of tattoo inks, carrier agents have ranged from water to sugar-cane juice to urine, and historically both tattoo pigments and the fluids used to make up an ink solution have been doctored with any number of substances that the tattoo artist or culture felt might aid in its magical or spiritual properties. Today, most tattoo artists buy their inks premixed, and carrier solutions used to make these mixes include alcohols, water, glycerin, and witch hazel.

tattoo instruments

Your skin is designed to protect your body in numerous ways, and is a remarkably tough organ. It goes without saying, therefore, that tattoo instruments need to be sharp. The array of sharp instruments used to

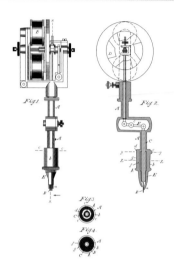

1891 Patent drawing by Samuel F. O'Reilly for his "Tattooing Machine"

introduce pigments into the skin for tattoos has ranged from all manner of bone and ivory implements to metal instruments and needles. Until the advent of the industrial revolution transformed tattooing, as it did every other facet of modern civilization, all tattooing carried out until 1892 was done by hand. Today the majority of tattoos in the Western world are produced using a tattooing machine (see page 28).

WHICH TATTOO?

Given that a tattoo is a deliberately inflicted injury to your skin and a decision not easily reversed, the choice of which tattoo mark to get should be seen as one of the more serious commitments you are going to make in life. Picking a tattoo does not have to be an agonizing decision, fraught with hand wringing and sleepless nights, but it should be something that you put some time and effort into. Better yet, it should be a process that engages your originality and imagination. So what kind of design is your tattoo mark going to be?

SYMBOLIC CONSIDERATIONS

"What does it mean?" When you get a tattoo, rest assured that this is a question you will be asked many times, by your friends, your family, and complete strangers at restaurants, bars, and the bus stop. What they are really asking of course is what does your tattoo design symbolize? Even if your tattoo is a simple floral design, people are going to want to know if it has any symbolic meaning. Why? Because that's just the way people are. Body art is one of the greatest icebreakers of all time. You'd better get used to it and seriously consider what your tattoo design represents and reveals about who you are, if anything at all.

Even the simplest tattoo designs can have great symbolic meaning. Symbols stand for or suggest something else by reason of relationship, association, convention, or accidental resemblance. Take a tattoo of a wolf for example. A wolf is a wolf is a wolf. Or is it? Depending upon your cultural reference point, a wolf may symbolize swiftness and cunning; courage and loyalty; a teacher figure or spirit guide; a creator figure; or a shape-shifter who aids shamans. If you think of Christ as a shepherd, then the wolf may represent Satan. In other words, depending upon what you believe, a wolf may symbolize virtue or vice. A particular tattoo design can express something you believe in or feel so profoundly that you have difficulty putting it into words.

> "LOVE LASTS FOREVER, BUT A TATTOO LASTS SIX MONTHS LONGER."
>
> ANON

GENDER CONSIDERATIONS

As you narrow down your tattoo design choices, it's worth keeping a few things in mind. While there are no specific differences between the tattoos of men and women, or the designs and symbols they choose, there are a number of trends worth noting, from both a design perspective and a cultural one. We still live in a world where perception is reality for many people, and that includes engaging in age-old stereotypes. As body art has gained increasing acceptance in mainstream popular culture, there is much less stigma today attached to individuals who are heavily tattooed. But for better or for worse, in many circles, extensive tattooing is still seen as more acceptable on men than it is on women. Beauty is not only in the eye of the beholder however; it is also a matter of personal choice.

The majority of men want tattoos that accentuate their masculine qualities, characteristics, and attributes, and their physiques. On the whole, women want tattoos that accentuate their feminine qualities; the aesthetic lines and curves of their physiques, but they also generally want a design that resonates on a more emotional and spiritual level than most men consider necessary.

For men, those design considerations mean that they are attracted to tattoo designs that are long-standing icons of male strength, fortitude, and courage. Men also gravitate to tattoo designs that emphasize the breadth of their chests, the width of their shoulders, and the size and bulk of their biceps and upper arms, while narrowing the hips. This is often accomplished by tattoo design styles and genres that are big, bold, and densely colored. Tribal tattooing, with its bold graphics and extensive use of solid blackwork, is an excellent example of this.

Women often choose tattoo designs that visually elongate their legs and arms, narrow the waist, and draw the eye to the natural curves of their hips and bust. Even when choosing

> "TATTOOS AREN'T MEANT FOR EVERYBODY AND THEY'RE TOO GODDAMN GOOD FOR SOME PEOPLE." LYLE TUTTLE, TATTOO ARTIST

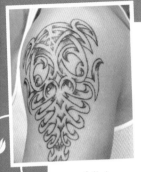

A tattoo on the upper arm or shoulder will emphasize its width

extensive tattooing, such as a full sleeve or a back piece, women may make use of a lighter and more delicate color palette, as well as a judicious use of negative space within the tattoo and a choice of a design that one might categorize as feminine. Additionally, women often use tattoo designs to symbolize important emotional milestones in their personal lives, such as the beginning or end of a relationship, a career transition, an emotional or personal evolution or transformation, or the triumph over illness or disease.

The butterfly design can be a small sexy secret or a larger tribute to a sense of adventure

negative connotations

It is worth remembering that some designs carry a tremendous amount of baggage with them. Designs that are used as symbols by gangs or extremist groups, or that are associated with hate crimes, are almost certainly ones that you should avoid. Most reputable tattoo artists, for example, would never dream of tattooing a swastika on a client. Tattoos of profanity, that are sexually explicit, or that might be racially offensive, will probably cause no end of grief when it comes time to get a job, and in some circumstances certain tattoo designs will make finding employment exceedingly difficult.

cost

Nowhere is the old adage "you get what you pay for" more applicable than when getting a tattoo, so be prepared to pay for excellence. The single worst decision you can make is to walk into a tattoo shop and try to get a tattoo design that matches the loose change you have in your pocket. A tattoo ranks right up there as one of the worst impulse purchases of all time, so take your time and choose the right design.

POSITION

It is important to accept that not all the skin on your body is the same, nor will it take tattoo pigment in exactly the same way. Tattoos on elbows, knuckles, knees, and feet are notorious for fading over time. Tattoos that bisect areas of the body where your skin is designed to crease—such as the inside of elbows and wrists—may result in lines spreading out, or what tattoo artists refer to as blow-out. These are also areas more likely to "tear" when being tattooed. A good tattoo artist is not going to want to tattoo any design on you that doesn't reflect well on them as an artist.

Remember also that tattooing certain body parts may offend potential employers—including the military services—and other members of the community.

SHAPE

What shape is the tattoo design? Is it triangular, circular or oval, vertical or horizontal? A horizontal tattoo design will make the part of your body it is tattooed on appear wider. A vertical design will elongate the body.

CONCEALMENT

Do you want people to be able to see the tattoo when you are in public? Once you are in a tattoo shop, the artist should be happy to discuss the best location for your design, even going to the time and effort of stenciling or roughing-in the tattoo to help you make the final decision.

SIZE

There is no question more dreaded by tattoo artists than "can you make it smaller?" Ideally, your tattoo design should be recognizable from several feet away, and one of the biggest regrets that people have regarding tattoos, especially the first one, is that they did not choose a larger size. With tattoos, bigger really is better. A larger tattoo design will allow your tattoo artist more room for shading, make it easier to outline and detail, and allow for the artistic embellishments that separate the truly great tattoos from the merely serviceable, such as an identifiable light source and the use of negative space within the design. You are going to be much happier with the results if you choose to get one tattoo that is extremely well executed rather than three small tattoos scattered about your body.

TOP TEN POPULAR BODY PARTS FOR TATTOOS

1. LOWER BACK

An extremely popular choice as a location for a woman getting her first tattoo. Sexy, sensual, exposed at the beach but covered up at the office; a tattoo in this position may be shared with a lover but hidden from the rest of the world.

2. ARM

Popular tattoo positions include the upper, lower, and forearm, shoulder and even sleeves.

3. BACK

The back is the largest blank canvas on the human body. Most tattoo artists will advise you to go as large as you can comfortably manage, and then even larger.

4. CHEST

The pectorals are a favorite spot for a tattoo to make a man's chest look larger.

5. WRIST

Wrist tattoos are very popular with young women, and can be hidden under a watch or bracelet if need be.

6. ANKLE

A design area popularized by supermodels and starlets.

7. FOOT

Tattoos on the feet tend to need a lot of touching up, because of their propensity to fade quickly.

8. ARMBAND

Although not a specific body part, the armband tattoo was once the staple in parlors around the world.

9. BREAST

The breast tattoo is enduring and popular with both sexes, for obvious reasons. For women a tattoo here is not only a sexual lure, but also one that can be concealed without too much difficulty.

10. NECK

Once a taboo area for most tattoo artists and enthusiasts, the explosion in tattooing in recent years has pushed back the boundaries of what meets the community standards of acceptable body art.

CHOOSING A TATTOO ARTIST AND STUDIO

If you have internet access, the nearest tattoo artist and studio are a mouse-click away on a search engine. If you've got this far on your tattoo journey, chances are you have already been doing some fairly extensive research. Tattoo artists are a little bit like mechanics. Some mechanics are generalists, and others tend to specialize in motorcycles or high-performance cars by a certain manufacturer. Most tattoo artists are proficient at working in a number of different tattoo styles and genres, but may specialize in one genre or style for which they have a special affinity and talent. If your heart is set on getting a dragon or a phoenix in the classic Japanese style of tattooing, you will be best served by making a list of artists in your area who have a reputation within that genre and, better yet, a portfolio of work demonstrating their prowess.

WHAT SHOULD YOU LOOK FOR IN A TATTOO STUDIO?

Tattoo studios come in all sizes, shapes, styles, and designs. A studio could be the sole purview of a single independent tattoo artist, or be run by an owner-operator with a shop manager, a counter person, and up to half a dozen artists. It may even be part of a chain of shops with multiple locations. And whether the shop is a throwback to the past or looks like an art gallery, some things are paramount. Cleanliness is next to godliness. Regardless of the shop location, the appropriate authorities for hygiene and sterilization and safety procedures should regularly inspect it. Depending upon where you live, this will fall under the jurisdiction of a Board or Department of Health, or Medical Examiner's Office. In North America, organizations such as the Alliance of Professional Tattooists, Inc. (APT) address health and safety issues affecting the tattoo industry, and facilitate programs to educate tattoo artists and teach standardized infection-control procedures.

"FOR SOMEONE WHO LIKES TATTOOS, THE MOST PRECIOUS THING IS BARE SKIN." CHER

SAFETY ADVICE

The APT has put together a list of guidelines to allow clients to judge whether or not a tattoo artist or studio is working cleanly and safely. For more information visit www.safe-tattoos.com.

With the advent of many communicable diseases—some fatal—it has become necessary to institute certain isolation and sterilization procedures in the tattoo process to ensure a risk-free tattoo. Professional tattooists working with local, state, and national health authorities have prepared the following advice (from the APT):

1 Always insist that you see your tattooist remove a new needle and tube setup from a sealed envelope immediately prior to your tattoo.

2 Be certain you see your tattooist pour a new ink supply into a new disposable container.

3 Make sure your artist puts on a new pair of disposable gloves before setting up tubes, needles, and ink supplies.

4 Satisfy yourself that the shop furnishings and tattooist are clean and orderly in appearance, much like a medical facility.

5 Feel free to question the tattooist as to their sterile procedures and isolation techniques. Take time to observe them at work and do not hesitate to inquire about their experience and qualifications in the tattoo field.

6 If the tattooist is a qualified professional, they will have no problem complying with standards above and beyond these simple guidelines.

7 If the artist or studio does not match these standards, or if they become evasive when questioned, seek out a professional tattooist. You should not get a tattoo from any shop in which you do not have complete confidence that such procedures are carried out.

After their apprenticeship many tattoo artists travel to other tattoo shops, often all over the world, to learn from an artist whose work they admire

WHAT SHOULD YOU LOOK FOR IN A TATTOO ARTIST?

When choosing a tattoo artist it can be useful to find out about his or her training. Most tattoo artists learn their craft through an apprenticeship program, which usually lasts three years. In Japan, an apprenticeship historically lasted five years. But that is usually only the beginning. Traditionally, tattoo artists take someone under their wing and pass on their knowledge acquired over many years. As a consumer, you should beware of the recent spate of tattoo schools that claim to teach people to tattoo in as little as six months.

Most tattoo masters will tell you that they didn't feel they had fully mastered the medium of working on human skin with tattoo machines and tattoo inks until they had been practicing their craft for a decade. Mastery is, of course, an entirely different matter than proficiency.

Training aside, what you really need to see are examples of tattoo work that you would be prepared to live with for the rest of your life. Any good tattoo artist will be happy to show you examples of actual tattoos in a portfolio of their work. Pretty pictures on paper are absolutely no indication of whether or not someone is a competent tattoo artist. Artistry and artistic talent are important, but body art is such an extraordinarily unique and difficult medium to master, you can really only make an informed judgment by scrutinizing the tattooist's work.

Whether you are looking at a tattoo in the flesh or in a photograph, you are looking for the same things. Is the tattoo part of a sleeve or a larger piece of work? If it is part of a larger piece of work, how does it complement the rest of the tattoo? If the tattoo is a solitary piece, how does it fit the body?

Does it fit the area tattooed? Does it accentuate and complement the body? If you see the tattoo in the flesh, does it flow well when the person moves?

If the tattoo is outlined, you are looking for confident, well-executed lines. Are power lines—the heavier lines—used effectively within the design of the tattoo? There shouldn't be any blow-outs, where the line has splayed out under the skin. Do the lines follow the natural contours of the body? If the tattoo contains shading, is the graduation from light to dark a smooth, consistent transition? If the tattoo uses colors, are they complementary? It can be difficult to judge, but is there evidence of an artistic vision in the tattoo? If shadows and shading are part of it, is the light source consistent? How has the artist utilized negative space—the areas of the skin that are not tattooed, or very lightly tattooed—within the whole design? Remember that what is not tattooed is every bit as important as what is.

BUDGETING

Tattoo artists generally charge either by the piece, or for their time. Any reputable artist can look at a design and tell within a few minutes how long it will take to execute. Charging by the hour is almost always done solely for large custom work involving many hours and multiple sessions, and even then, both artist and client have a rough idea of what is involved. When budgeting, bear in mind the unique mathematics of tattooing.

A 2-in (5-cm) tattoo of a butterfly is roughly 2 x 2 in (5 x 5 cm), or 4 sq in (25 cm^2). However, a tattoo design that is 4 x 4 in (10 x 10 cm) will cover 16 sq in (100 cm^2); in other words, it is four times as large as the first design. Chances are the tattoo artist is not going to charge you four times as much for the larger tattoo, but they are going to have to factor in the amount of time it will take to tattoo an area that is four times larger. And that will absolutely be reflected in the price of the tattoo.

> "THERE IS NO PERFECT BEAUTY THAT HATH NOT STRANGENESS IN THE PROPORTION."
>
> SIR FRANCIS BACON, LONDON, 1639

THE TATTOOING PROCESS

When you have chosen your design, placement, studio, and artist, you are ready to get your tattoo. Some tattoo shops will tattoo people on a first-come, first-served basis. Other shops will book appointments and often ask for a deposit that you may forfeit if you miss the appointment. This is because even the simplest tattoo is probably going to take at least 30 minutes to execute, and most will take from 60 to 90 minutes and beyond. Unless you are getting a traditional hand-tapped or hand-poked tattoo, your tattoo artist will use an electrical tattoo machine, and you can expect the tattooing process to follow a series of procedures.

PREPARATION

Before attending your tattoo appointment you should ensure that you are well fed and well hydrated. You should not be intoxicated. If you are, your appointment will probably be canceled. And yes, getting a tattoo hurts, but it doesn't hurt so much that you need to be inebriated or sedated. Think of the pain involved as an integral part of your personal rite of passage.

The tattoo artist will start by "prepping" you for the tattoo. This entails shaving off the hair from the tattoo site and wiping the area with isopropyl alcohol, a sterilizing agent. Generally, the artist will then make a stencil of your tattoo, at which point you and the artist will come to an agreement with regards to its exact placement. This is the last opportunity you are ever going to have to say, "I want it a little to the left" or "Could you move it up a little?" Speak now or forever hold your peace.

After pulling on disposable surgical gloves, the artist will take new sterilized needles and tattoo machine tube assemblies from sealed envelopes that have come out of an autoclave. They will then assemble their machine. The tattoo artist will usually examine the tips of their tattoo needles under a jeweler's loupe or magnifying glass to ensure that the needles are sharp and not bent over or hooked. They will then pour fresh ink into new disposable ink containers.

> "GOOD TATTOOS AREN'T CHEAP AND CHEAP TATTOOS AREN'T GOOD."

OUTLINING

Outlining the design is the first stage of the actual tattooing process. The artist usually smears petroleum jelly on the stencil, allowing their gloved hand to slide easily over the skin, then generally works in one direction over the stenciled tattoo design. During the outlining the artist will wipe away excess tattoo ink and blood with a paper towel.

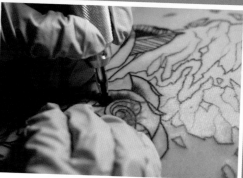

The tattoo is outlined in black ink and then shaded using fine gradations of color

Outlining is usually carried out with needle setups called outliners or rounds. These are groups of needles, ranging from one needle for fine lines, to three, five, and seven. The larger the number the artist uses, the thicker and stronger the line. A heavy line is called a power line, and is used to give weight to the design and create tension and a sense of movement.

SHADING

Once the outlining is finished, the artist will clean off the skin and begin shading. In creating fine graduations, the artist may dilute the tattoo ink—as much as 20 or 30 parts water to one part ink—to create a gray wash. When adding color to the tattoo design the artist is careful to ensure solid, even coverage, taking care not to leave any "holidays," or areas where the ink has "taken a vacation." Working with the principles of the color wheel, the artist generally works from the lightest to the darkest colors.

A good tattoo artist prefers not to overwork a tattoo design and "chew up" or "velvet" the skin, which may cause scar tissue as the tattoo heals. If necessary, most artists would prefer a client return later to get the tattoo touched up. Many of the very best tattoo artists have a proprietary sense of ownership over their work and will touch up a tattoo over its life to ensure that their work always looks its best.

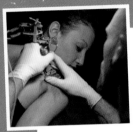

Tattoo artists prefer to maintain and touch up their own work

FINISHING

When the artist is satisfied that they have done all that they can do, they will wipe off and clean up the tattoo and let it sit. Then they will wipe away the last of the blood and plasma, and bandage the tattoo.

TOUCH UPS

All colored tattoos are going to fade with time. Yellows, oranges, and reds tend to fade the quickest. Blacks are the least likely to fade, but over time the pigments are likely to dissipate slightly, giving the effect that the edges of your tattoo are slightly blurry. Therefore, over time your tattoo will almost inevitably need a little freshening up. Don't we all? Most tattoo artists prefer to look after and maintain their own work, so consult with your tattoo artist when the time comes.

REMOVAL AND COVER-UPS

Tattoos can be removed, although the removal methods are expensive, time-consuming, and quite often painful, and the results may be mixed. Small tattoos may be surgically removed, but there will be some scarring, and the same is true of dermabrasion removal. Recent advances in laser technology have made laser removal the first choice for most cosmetic and plastic surgery practices. However, for every dollar you spent getting your tattoo, expect to spend four dollars removing it. Now that's painful, so think before you ink.

Tattoo cover-ups are not uncommon. The tattoo you got when you were 18 that was small is now dated, and can be hidden in a larger tattoo. That said, most cover-ups are compromises to some extent. If the first tattoo is small, it is less of a concern. But if, for example, it's a relatively large tribal piece, you have to bear in mind that the only thing that covers up black is even more black. At some point you are dealing with a case of diminishing returns and it may just be best to accept your tattoo as either a youthful indiscretion (and who among us doesn't have at least one of those?) or see the tattoo as unique to that particular time and place in your life.

ͲΑͲͲΟΟ ΑϜͲΕΡϹΑΡΕ

A new tattoo is a wound and should be treated accordingly. The bandage should remain on as a barrier to infection for at least a few hours before removal. For the next ten days, treat the tattoo as you would severe sunburn.

1 Wash it in cool or warm water with a mild antibacterial soap; pat the area dry and do not rub it.

2 Take particular care with tattoos that may be rubbed by clothing straps or tight waistbands or belts.

3 Do not soak your new tattoo in water, and keep it out of chlorine. Many vacation tattoos end up with problems because the client goes swimming.

4 The skin is going to peel with any new tattoo, but if a scab forms, do not pick at it.

5 Keep it out of the sun.

6 Use ice for redness or swelling. If there is any sign or indication of an infection, seek medical assistance.

ͲΗΕ ЅVП

The sun is a nuclear furnace, constantly bombarding us with radiation. Using sunscreen is the most effective way to protect your tattoos from the sun, and at the same time you can protect the rest of your skin as well.

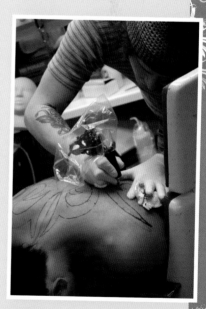

Care for your new tattoo as you would care for severe sunburn or a wound

TATTOO
CULTURE

ASIA POLYNESIA NORTH
AMERICA SOUTH AMERICA
AFRICA MIDDLE EAST
EUROPE

jAPAп

The first evidence of Japanese tattoo design can be seen on clay figurines recovered from tombs. Thought to date back to 5000 BC, their faces had been etched and painted with simple marks and lines, believed to indicate social rank and to protect from evil spirits. Chinese historical texts from the third century AD speak of Japanese men and boys decorating their faces and bodies with tattoos. There is also mention of Japanese fishermen painting their bodies to protect themselves from large fish when they dove for shells.

BAпiSHED BV† пo† FORGO††Eп

By the early seventh century, the rulers of Japan had adopted much of the culture and attitudes of the Chinese, and as a result decorative tattooing fell into official disfavor. Tattooing in Japan became taboo, a mark largely reserved for the outcast and criminal. Those wearing tattoos were ostracized; essentially doomed to live outside the domain of family and society. The first report of Japanese tattooing as punishment was recorded in a history dating

> "SHOW ME A MAN WITH A TATTOO AND I'LL SHOW YOU A MAN WITH AN INTERESTING PAST."
> JACK LONDON, 1883

from AD 720, when the Emperor summoned before him Hamako, Muraji of Azumi, saying: "You have plotted to rebel and overthrow the state. This offence is punishable by death. I shall, however, confer great mercy on you by remitting the death penalty and sentence you to be tattooed."

However, the indigenous Ainu people enjoyed a different esthetic code. Living on Hokkaido, the most northern of the Japanese islands, they considered their young girls beautiful for receiving decorative tattoos on their lips, legs, arms, and hands. Although no longer practiced today, as recently as the 1980s elderly Ainu women still showed the tattoos they received as young girls.

By the early seventeenth century a generally accepted codification of tattoo marks was used to identify criminals and outcasts in Japan. Outcasts were tattooed on the arms—perhaps a cross on the

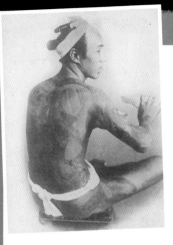

Hand-tinted photograph of Japanese tattooing, 1890s

form of punishment. By the end of the seventeenth century, other forms of punishment had largely replaced tattooing, and decorative tattooing began to emerge. The practice was illegal, but became popular among the criminal classes, who transformed their "marks of the criminal" into something more beautiful. It was also popular with firefighters, who employed water symbols as amulets of protection in their dangerous work. The relationship between masculine attributes and aesthetic sensibilities was thereby established.

Around the middle of the eighteenth century, a popular Chinese novel, *Suikoden*, which included many heavily-tattooed heroes, stimulated the popularity of tattooing. The Japanese version of *Suikoden* was illustrated by a variety of artists, each of whom created prints with new interpretations of the tattoos described in the novel.

Pictorial tattooing flourished during the eighteenth century in connection with the popular culture of Edo, as Tokyo was then called. In the early part of the century the Japanese woodblock print—also known as *ukiyo-e*—was developed to meet the needs of publishers who

inner forearm, or a straight line on the outside of the forearm or on the upper arm. Criminals were marked with a variety of symbols that designated the places where the crimes were committed. In one region, the pictograph for "dog" was tattooed on the criminal's forehead. Other marks included patterns featuring bars, crosses, double lines, and circles on the face and arms. Tattooing was reserved for those who committed serious crimes, and individuals bearing tattoo marks were ostracized by their families and denied all participation in community life. For the Japanese, tattooing was a severe and terrible

required illustrations for novels, and theaters that needed advertisements for their plays. The development of the woodblock print parallels, and had a great influence on, the development of tattooing.

Despite the ban, tattooing continued to flourish, in particular among members of the Yakuza— traditional organized crime gangs— outlaws, penniless peasants, and laborers who migrated to Edo in the hope of improving their lives. The Yakuza felt that because tattooing was painful, it was a proof of courage; because it was permanent, it was evidence of lifelong loyalty to the group; and because it was illegal, it made them outlaws forever.

tattoo masters

By 1867, the last of the Tokugawa shoguns was deposed and an emperor was restored to power. The laws against tattooing were strictly enforced because the new rulers feared that Japanese customs would seem barbaric and ridiculous to Westerners. Ironically, under the new laws, there was no law against tattooing foreigners. Tattoo masters set up business in Yokohama and were kept busy tattooing foreign

Japanese wood block print, 1800s

sailors. So great were their skills, that foreign kings and emperors traveled to Japan to receive tattoos from the great masters of the day.

The Japanese tattoo masters also continued to tattoo Japanese clients illegally. The tattooist in Japan was considered a highly skilled craftsman and underwent a rigorous apprenticeship, living with his master for five years. He was called *horimono*, to distinguish him from the carvers of woodblocks, who were called *hori*, which means "to carve, scrape, or inscribe." An important skill acquired through apprenticeship was a full understanding of the meanings of the traditional designs. Classical Japanese tattooing is limited to particular designs representing legendary heroes and religious motifs, which are combined with specific symbolic animals and flowers, and set off against a background of waves, clouds, and lightning bolts. Integral to the designs was an elaborate system of symbols that combined the

principles of yin and yang; the use of negative space within the art; an aesthetic appreciation for the lines of the human body; and the art of telling a story through the use of specific images; all of which were meant to reveal the character of the individual through the tattoo. The untrained tattooist might not appreciate the importance of expressing all four seasons on the skin, or he could reveal his ignorance by incorporating both snake and cherry blossom in the same scene (snakes are in hibernation when the cherry tree blossoms).

TRADITIONAL DESIGNS

Traditional Japanese tattoos differ from Western tattoos in that they consist of a single major design that covers the back and extends onto the arms, legs, and chest. The design requires a major commitment of time, money, and emotional energy. The original designs were created by some of the best woodblock artists. The tattoo masters adapted and simplified these designs to make them suitable for tattooing, but didn't invent the designs on their own. During most of the nineteenth century, an artist and a tattooist worked together. The artist drew the picture with a brush on the customer's skin, and the tattooist copied it.

THE MODERN ERA

In 1936, fighting broke out in China, and almost all Japanese men were drafted into the army. Those with tattoos, however, were thought hard to discipline, and were not drafted. After World War II, General MacArthur liberalized the Japanese laws, and tattooing became legal again, yet the practice remained concealed from the public eye. Tattoo artists worked privately through appointments, a tradition that continues today.

In modern Japan, displaying one's tattoos in public is still not generally accepted. It is considered the domain of the underclasses and those involved in organized crime, although these attitudes are rapidly changing. Hotels and bars hoping to deter rowdier clientele may ban those sporting visible tattoos.

Tattooed Yakuza at a shrine festival in Tokyo, Japan, 2006

BORΠEO

Borneo is one of the few places in the world where traditional tattooing is still practiced today. And while the tattoos of Polynesia sparked a revival of tattooing in the West after the encounters of Captain Cook and his sailors in the eighteenth century, it could be argued that the designs of modern tribal tattooing—large bold black graphic designs—find their roots in the indigenous tattoos of the diverse ethnic groups of the island of Borneo. Traditional tribal tattooing on men includes large zoomorphic designs representing dogs, scorpions, crabs and many other symbols, that swirl and are intricately interwoven, and that cover significant portions of the arms, legs and torso.

Archeological evidence has shown that ancestors of some contemporary tribes have lived in Borneo for at least 40,000 years. It is impossible to know with certainty how long tattooing has been practiced by the Dayak people, but tattooing was closely connected to their spiritual beliefs in animism, where the jungle was inhabited by all manner of spirits, both good and evil, and the practice of headhunting. Tattoos told the story of an individual's life, recorded their accomplishments and deeds in battle, and served as amulets that offered protection from spirits and other mishaps. The term, "Dayak" is applied to a variety of native tribes including the Ibans, Kayans, and Kenyahs.

"A MAN WITHOUT TATTOOS IS INVISIBLE TO THE GODS."

IBAN PROVERB

Traditional Iban tattoos in Borneo

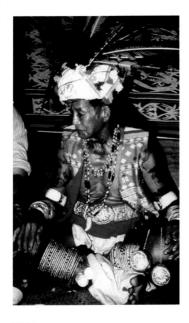

*An Iban elder at a skull
ceremony in Borneo*

motifs found in the art of Bali and
Java, and the tattooing instruments
and techniques used by the Dayaks
were similar to those found
throughout Polynesia, suggesting
that Stone-Age voyagers shared their
knowledge throughout the area.

If a Sarawak Kayan had taken the
head of an enemy, he could have
the back of his hands and fingers
covered with tattoos, but if he only
had a share in the slaughter, one
finger only, and generally the thumb,
could be tattooed. On the Mendalan
River, the Kayan braves were tattooed
on the left thumb only, not on the
carpals and the backs of the fingers,
and a thigh pattern was reserved for
head-taking heroes.

MEN

Headhunting and tattooing were
intricately connected with the magic,
ritual, and social life of many tribes
in this region. The hand tattoo was
a symbol of status in life and also
served an important function after
death, when it was supposed to
illuminate the darkness as the soul
wandered in search of the River of the
Dead. Tattooing, piercing, and other
traditional Dayak arts are of great
antiquity. Many of the traditional
tattoo designs resembled decorative

WOMEN AND GIRLS

Kayan women may be tattooed in
complicated serial designs over
the whole of their forearms, the
backs of the hands, the whole of the
thighs to below the knees, and on
the metatarsal surfaces of the feet.
The tattooing of a Kayan girl takes
up to four years. At 10 years old a
girl could have her fingers and the

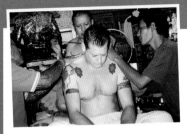

Thai Tattooing in Wat Bang Phra

upper part of her feet tattooed, and about a year later her forearms would be completed. The thighs would be partially tattooed during the next year, and in the third or fourth year from the commencement the whole operation should have been accomplished. Her tattoos would be completed before pregnancy, because it was considered immodest to be tattooed after a woman has become a mother. Tattooing among the Kayan women was universal, and they believed that the designs acted as torches in the next world. Women, never men, perform the operation of tattooing but men actually carve the designs on wooden blocks.

tATTOOinG tECHniQVE

The tools used by a tattoo artist are simple, consisting of two or three prickers and an iron striker, kept in a wooden case. A pricker is a wooden rod with a short, pointed head projecting at right angles at one end. Attached to the point of the head is a

lump of resin, which is embedded with three or four short needles. The striker is merely a short iron-clad stick, half of which is covered with a string lashing. The pigment is a mixture of soot, water, and sugar-cane juice, and is kept in a shallow wooden cup. The best soot, according to tradition, comes from the bottom of the metal cooking pot. The tattoo designs are carved in high relief on blocks of wood that are smeared with the ink and pressed on the part of the body to be tattooed, leaving an impression of the designs. The subject to be tattooed lies on the floor, with the artist and an assistant squatting on either side. The artist dips a piece of fiber from the sugar palm into the pigment and, pressing this on the limb to be tattooed, plots out the arrangement of the rows or bands of the design. The tattooist or assistant stretches the skin to be tattooed using their feet, and dipping a pricker into the pigment, taps its handle with the striker as she works along a line, driving the needle points into the skin. The operation is painful and there is no antiseptic; often a new tattoo ulcerates.

†HAİLAПD

Thailand is the only country in the world with a tattoo tradition that has an annual religious celebration. Once a year, thousands of tattoo enthusiasts from around the world, with gifts of incense and flowers for the tattooist's venerable teacher, descend on the Wat Bang Phra—also known as the Temple of the Flying Tiger—located about 30 miles (50 km) from Bangkok, where dozens of heavily tattooed Buddhist monks are masters of the tattoo art. Unlike most tattoos in the West, the Thai version comes steeped in spiritual, or some might say superstitious, meaning. Protection, good luck, and blessings from on high are what the tattoo devotees are seeking. Many arrive already heavily tattooed and are there to simply get their designs "recharged" by having the Buddhist monks re-bless their body art. During the festivities it is not uncommon for the tattoo devotees, through their chanting, to reach an extremely heightened state of consciousness, appearing to enter into a trance.

It is a long tradition in Thailand for soldiers to take on these protective tattoos, called *sak yant*. The belief in their powers as charms is so great that it's commonly believed that the right tattoo by the best tattoo master can stop bullets.

SPİRİTUAL †A††OOS

It's not only the Buddhist designs that are potent, but the accompanying prayers. The monks chant them as the nearly yard-long tattoo implements do their work. The fingers of one hand direct the needle, cradling the tip almost as if it were a pool cue, while the other hand drives the needle up and down. The monk's wrist is a blur as he maneuvers the needle in and out of the skin,

Traditional Thai tattoo

two or three times per second. The resulting series of connected dots in the skin resembles an embroidered tapestry. The hand-tapped tattoos are painful, but it's a fair exchange if you believe that you walk away from the experience invincible.

Another technique involves the tattooist's needle penetrating the skin, after which ink is rubbed into the wound and a prayer spoken to impregnate the charm with its spiritual power.

The art of spiritual tattooing as practiced in Thailand is one that goes back to ancient times. Like the classical Japanese tattoo masters, the Thai monks undergo the long training necessary to find that mystical place inside them where they aren't distracted. Only in that state—and working from that very still place— can the tattooist orchestrate his mind, body, and heart into the necessary coordination to perform the tattoo miracle. It not only takes a monk to recite the appropriate *sutra*—there are at least 108 of them—it takes a person whose heart is purged of his own agenda and egocentricity. Only then will the tattoo be a pure design, able to answer the wearer's prayers. Thai traditionalists would warn

tattoo enthusiasts that ordinary decorative tattoos have no power to protect or bless them. Decorative tattoos in the traditionalist's eyes are executed using modern electric machines in the hands of tattooists with little true feeling, and consequently the tattoos lack authority and integrity. Mainly, they are perceived to lack magic. Such tattoos would have little power to act as a protective amulet or talisman or to bring good fortune to the wearer.

TRADITIONAL MOTIFS
There are hundreds of traditional Thai designs, many of them animals. Of these, the tiger is the most popular. The lower back is the preferred location for this most powerful of motifs. Taking a tiger tattoo is to take on the tiger spirit; a spirit that will be in control of your life. In 2004 Angelina Jolie submitted to the classical tiger treatment at the hands of venerated tattoo master Ajarn Noo Kanphai.

The most popular Thai tattoos depict Buddhist deities or temples. Often, the tattoo is not a recognizable image at all, but Thai script reproducing prayers. Sometimes it's a *yantra*, a pattern that is much less

graphic than a tiger and composed of dots.

Of the various Thai tattoos said to attract luck, wealth, and blessings —as well as provide a measure of insurance against evil spirits—the traditional Buddhist tattoo is very popular. It's usually a geometric design based on images of the Buddha, bodhisattvas, the lotus, or some other Buddhist symbol. The Thai also have a Hindu Sanskrit tattoo that performs much the same function, except that it's based on Hindu gods and deities, such as Brahma, the four-faced Buddha, Hanuman the monkey god, the holy eagle, the heavenly dog, the Thai dharma king, and a female wealth deity. These are fearsome creatures, in the face of which most evil spirits are said to quickly retreat.

For luck, wealth, and blessings you could also choose one of the Thai lucky holy icons, such as the tiger or dragon, the phoenix, lion, leopard, or snake. These animals are both holy and lucky, but aren't complete as a tattoo unless they're surrounded with appropriate mantras and *yantras*, and applied by a monk chanting the sutras. There's even a special Thai tattoo to improve your interpersonal

skills, called the golden-tongued bird or *sha li ka*. They say it improves your confidence and speaking skills, and it had better work because it must hurt, since it's applied to the tongue. Not as painful is the tattoo inked onto the top of the back of the head, the *yuan shen guan ding*, which is intended to fill your head with blessings to protect your soul. In Thai tattooing, the closer a tattoo is to the head, where the soul is thought to reside, the greater the power it is thought to have.

THE "INVISIBLE" TATTOO

Thai tattooing has adapted to modernity with typical finesse and subtlety. Those who fear that their tattoos may not be well received in an office modeled after its Western counterparts may get tattoos not with the usual tattoo inks, but with sesame oil, or even no pigment of any kind. The tattooing implements, the designs, and the mantras are all the same. The result, however, for all intents and purposes, is an "invisible" tattoo, with none of the visible stigma of a tattoo, but with all its magical powers intact.

POLYNESIA

Polynesian tattooing, as it existed before the arrival of Europeans, was among the most intricate and skilled in the ancient world. It had evolved over many hundreds of years and was characterized by elaborate geometrical designs. The tattoos were often renewed and embellished throughout the life of the individual, until they covered the entire body.

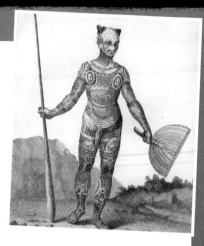

c.1800, a native of the Marquesas Islands, tattooed from head to toe

ANCIENT TRADITION

It was in Tonga and Samoa that the Polynesian tattoo developed into a highly refined art. According to Samoan tradition, a pair of sisters who swam from Fiji carried the art of tattooing to Samoa. As they swam they sang tattooing songs, but during the long trip they grew tired and confused, and where once it was women who were heavily tattooed and men lightly tattooed, by the time they got to Samoa it was the men who were heavily tattooed and the women lightly so.

Tongan warriors were tattooed from the waist to the knees with a series of geometrical patterns, consisting of repeated triangular motifs, bands, and areas of solid black. Priests who had undergone a long period of training and who followed strictly prescribed rituals and taboos during the process executed the tattooing, and for the Tongan the tattoo carried profound social and cultural significance.

In ancient Samoa, tattooing played an important role in both religious ritual and warfare. The tattoo artist held a hereditary and highly privileged position. He customarily tattooed young men in groups of six to eight, during a ceremony attended by friends and relatives. The Samoan warrior's tattoo began at the waist and extended to just below the knee. Samoan women were also tattooed, but female tattooing was limited

to a series of delicate, flowerlike geometrical patterns on the hands and lower part of the body.

DEVELOPING CULTURES

In about AD 200, voyagers from Samoa and Tonga settled in the Marquesas, a group of 12 islands isolated in the Pacific, some 1,200 miles (1,900 km) west of Peru. Over a period of more than 1,000 years, one of the most complex Polynesian cultures evolved. Marquesan art and architecture were highly developed and Marquesan tattoo designs, which in many cases covered the whole body, were the most elaborate in Polynesia. By AD 1000, the Polynesian peoples had colonized most of the habitable islands east of Samoa. Distinctive cultural traits evolved in the island groups, as did unique languages, myths, arts, and tattoo styles.

The naturalist Sir Joseph Banks was the first European to speculate as to the motive for tattooing among the natives of Polynesia. During his visit to Tahiti on Captain Cook's 1769 voyage, he wrote:

> "THE UNIVERSALITY OF TATTOOING IS A CURIOUS SUBJECT FOR SPECULATION."
>
> CAPTAIN JAMES COOK, 1779

What can be sufficient inducement to suffer so much pain is difficult to say; not one Indian (though I have asked hundreds) would ever give me the least reason for it; possibly superstition may have something to do with it. Nothing else in my opinion could be a sufficient cause for so apparently absurd a custom.

Members of Cook's crew were among the first Europeans to acquire Polynesian tattoos, and the practice quickly spread throughout the British Navy. Sailors learned the technique from Polynesian artists, practiced it onboard ship, and later established tattoo parlors in European port cities.

Contact with Europeans, and the influx of missionaries, took a heavy toll on traditional cultural practices across Polynesia. In Tahiti for example, Emperor Pomari II banished all traditional tattooing in 1817 when he converted to the Catholic church. Hawaii was another island culture that lost many of its original tattoo designs, and the meanings behind the symbols.

SAMOAN TATTOO TOOLS

The instruments of the *tufuga,* the so-called *au,* resemble hoes or rakes, but are of varying width. The comblike serrated part of it, which comes into contact with the skin, is made of bone, or occasionally the ivory of a pig's tusk. The preferred material is human bone, but if none are available then horse or ox bones are used. The toothed part of the implement, which pierces the skin, is connected to the actual handle by a hoe, which usually consists of tortoiseshell. The handle is made of cane or wood, and the parts are tied together with coconut fiber. A complete set of tattooing instruments consists of 8 to 12 implements, depending on the artist. A short wooden mallet is used to strike the tattooing instruments near the tip and to drive the teeth into the skin. Samoan tattooing is considered to be among the most painful in the world, and a true test of stoicism.

The Samoan method of tattooing requires that the tattoo master have several assistants , or "stretchers" at hand. It is their job to stretch the skin taut enough to enable the tattoo implements to penetrate it more easily, facilitating the tattooing. While stretching the skin, they are also learning the art of tattooing.

SAMOAN TATTOOING

The first Europeans to set foot on Samoan soil were members of a 1787 French expedition who had a close look at natives and reported, "the men have their thighs painted or tattooed in such a way that one would think them clothed, although they were almost naked." When missionaries arrived, tattooing was one of the customs that they tried to suppress. One missionary wrote: "Tattooing is among the works of darkness and is abandoned wherever Christianity is received." However the Samoans saw Christianity as something they could add to their culture, not as something to replace it. For young Samoan men, tattooing was a rite of passage from boyhood to maturity.

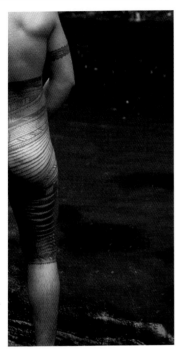

Samoan man with a full body tattoo

A young man who was not tattooed was considered still to be a boy. He could not marry; he could not speak in the presence of grown men; and he was obliged to perform menial tasks. The fact that he sometimes attended Sunday services held by missionaries was no reason to give up tattooing.

TATTOOING IN THE MARQUESAS

The Marquesas were colonized in AD 200 by Polynesian voyagers who had already brought tattooing to a high level of sophistication. During the latter part of the eighteenth century, explorers, traders, and whalers in need of provisions occasionally visited the Marquesas. None stayed long, but deserters and mutineers sometimes remained on shore until they could be picked up by another vessel. Adam Johann von Krusenstern, a German explorer in Russian service, arrived in the Marquesas in 1804 and found two Europeans living among the natives. They were a Frenchman, Jean Baptiste Cabri, and an Englishman, Edward Robarts. Both men had lived on the islands for several years and had been tattooed in the Marquesan fashion. Krusenstern employed them as guides and interpreters, and Georg Heinrich von Langsdorff, the German naturalist who accompanied Krusenstern, used them as informants when he wrote the first published account of native life and customs.

Langsdorff was interested in Marquesan tattooing because it was

far more extensive than that of other Pacific islands. Most Marquesans were completely covered, including hands, feet, and faces, with intricate geometric designs. An artist who accompanied the Russian expedition, W. G. Tilesius von Tilenau, made the first drawings of tattooed Marquesan natives. For almost a century, von Tilenau's illustrations were widely reproduced and were an invaluable record of authentic Marquesan tattooing as it was before contact.

Willowdean Handy studied the tattoo art of the Marquesans for many years and wrote three books in the 1920s and 1930s describing her adventures: *Tattooing in the Marquesas; Forever the Land of Men;* and *Thunder from the Sea.*

Tattooing in the Marquesas contains photographs and many drawings of ancient designs. In addition, Handy summarized the information collected from interviews.

Herman Melville famously jumped ship in the Marquesas, and he vividly recounted his memories of tattoos when writing *Moby Dick.*

mĀori tattooing

Tā moko, or *moko*, a traditional form of Māori tattooing, differed from the form of marking used by other Polynesian peoples in that the marks were incised into the skin to make scars. While much Polynesian tattooing was derived from straight-line geometric patterns that most suited the Polynesian tattoo combs, Māori tattooing was essentially curvilinear, and the designs were based on the spiral. Māori tattooing is distinguished by the use of bold lines and the repetition of specific design motifs that are prominent in the tattooing and other cultural artworks, such as carving and weaving, of the Māori people of New Zealand. Within Māori facial

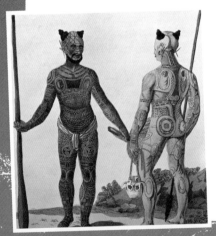

Color engraving of tattooed warriors in Nuku Hiva, Marquesas Islands

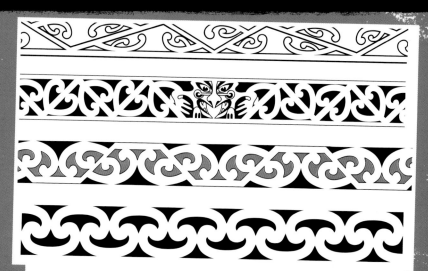

Popular Māori tattoo designs

tattoos it is possible to discern two spiral patterns very similar to the fern frond that is a repeating motif common to Māori art (see page 51).

A traditional Māori tattoo artist—the *tohunga-ta-moko*—could produce two different types of pattern: that based on a pigmented line; and another based on darkening the background and leaving the pattern unpigmented. Traditionally Māori tattoo artists followed very specific rules, although because of the tremendous cultural complexity of New Zealand's many tribes and clans, these rules often had local variations. However, the idea that the tattoos followed a set of prescribed rules was widespread, and tattoos were specific to individuals, families, clans, and tribes. Māori tattoos followed the contours of the face, and were meant to enhance the natural contours and expressions of an individual's face. Similarly, tattoo designs on other parts of the anatomy, such as the buttocks and thighs, also followed the natural contour lines. A well-executed tattoo would trace the natural "geography" of an individual's facial features.

With the exception of slaves and commoners, all men were tattooed on the face and most were also tattooed on other parts of the body. An elegantly tattooed face was a source of pride to the warrior, for it made him fierce in battle and

The supply of guns was inexhaustible, but the supply of heads was not, and soon the Māoris were getting desperate. Slaves and commoners captured in battle were tattooed and killed so that their heads could be sold. And even heads of poor quality, with mediocre or unfinished tattooing, were offered for sale. When pressure from colonization caused encroachment on Māori lands, the Māoris came into armed conflict with the British. Ultimately, the Māoris were no match for the modern British Army, many of whom greatly admired the Māori's courage in battle, and they were forced to give up nearly all of their traditional territories with the expansion of British settlements. Once stripped of their land, the Māori men, a fiercely proud band of warriors, lost interest in tattooing and other traditional skills. Tattooing among women did, however, continue for another half century, and the facial tattoos of the Māori "grannies" were a poignant and powerful cultural reminder to the Māori right up until the 1980s, at which time there was a strong revival in traditional Māori cultural practices.

In 1873, an artist named Gottfried Lindauer arrived in New Zealand and was fascinated by the Māori. By the end of the nineteenth century he had completed over 100 portraits, which are now part of a priceless collection in the Auckland Art Gallery. Lindauer's work is of great historical value because it is a precise record of some of the most artistic and sophisticated tattooing that was ever produced. Many of the Māori individuals who sat for their portraits had played leading roles during New Zealand's formative years. In 1896 the military man, writer, illustrator, and great admirer of the Māori people, Major General Horatio Robley, published the book *Moko, or Māori Tattooing*, which is the standard reference for New Zealand Māori tattooing, although some of his claims about tattooing practices are disputed by a number of modern Māori scholars.

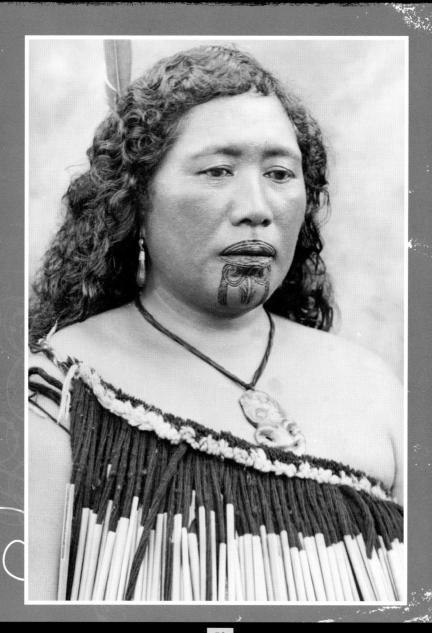

ΠAtive ΠΟRth AmERICA

Most nineteenth-century scholars took little, if any, interest in native North American tattooing and very little information can therefore be found. However, brief references to tattooing appear in the writings of seventeenth-century Jesuit missionaries whose reports were sent to Paris and compiled in volumes titled *Jesuit Relations.* Jesuit missions were scattered through Canada, and missionaries reported that tattooing was practiced by almost all the native tribes they encountered.

VARYiΠG BELiEFS
Native North American tattooing was often associated with religious and magical practices, and used as a symbolic rite of passage between adolescence and adulthood.
Many tribes practiced therapeutic tattooing. The Ojibwa tattooed the temples, forehead, and cheeks of those suffering from headaches and toothaches that were believed to be caused by malevolent spirits. Songs and dances that were supposed to exorcise the demons accompanied the tattooing ceremony.

The Sioux believed that after death the spirit of the warrior mounts a ghostly horse and sets forth on its journey to the "many lodges" of the afterlife. Along the way the spirit will meet an old woman who blocks his path and demands to see his tattoos. If he has none, she will turn him back and condemn him to return to the world of the living as a wandering ghost.

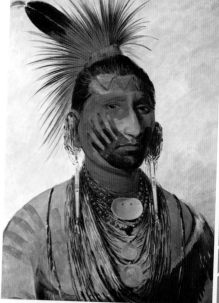

Painting of Chief Ojibwa by George Catlin, 1796

Tattooing was also used to honor warriors who had distinguished themselves by bravery in combat. European travelers reported the use of tattooing to record achievements in war. In the *Jesuit Relations* of 1663, it was reported that an Iroquois chief known to the French as "Nero" bore on his thighs 60 tattooed characters, each of which symbolized an enemy killed with his own hand.

Sylvia Ivalu in Atanarjuat, The Fast Runner, *2001*

THE ARCTIC

The inhabitants of St. Lawrence Island in the Bering Sea have a tattoo history dating back over 3,500 years. Tattooing was practiced by all Inuit and was most prominent among women. An early reference was made by Sir Martin Frobisher in 1576. Frobisher's account describes the Inuit he encountered in the bay that is now named after him:

> The women are marked on the face with blewe streekes down the cheeks and round about the eies . . . Also, some of their women race (scratch or pierce) their faces proportionally, as chinne, cheeks, and forehead, and the wristes of their hands, whereupon they lay a colour; which continueth dark azurine.

As a general rule, expert tattoo artists were respected women elders. Their extensive experience as skin seamstresses—making parkas, pants, boots, boat covers, and so on—meant they had the type of precision that was needed to produce tattoos. Tattoo designs were usually made freehand, but in some instances a rough outline was first sketched.

PACIFIC NORTHWEST

The Haida were the most accomplished of all North American native artists and craftsmen. Their totem poles, canoes, and dwellings were embellished with traditional designs associated with mythical and totemic themes.

James G. Swan wrote the only scholarly first-hand account of native tattooing in North America. He felt

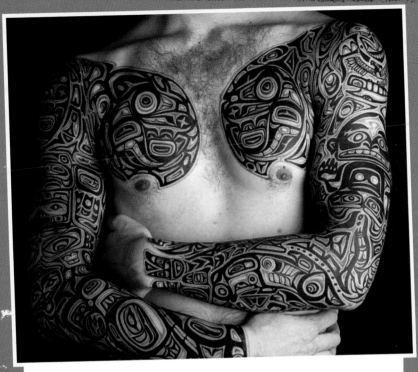

Haida-style tattoo art by Jonathan Shaw

that natives should be considered worthy of respect and he wrote accounts of their rapidly vanishing culture in *The Northwest Coast*, which was first published in 1857. In 1874, Swan's monograph, *The Haida Indians of Queen Charlotte's Islands, British Columbia* was published by the Smithsonian Institution and in 1878 *Tattoo Marks of the Haida*

appeared. Swan had hoped to get government money to further study native tattooing but the government refused to fund the project. In *Tattoo Marks of the Haida*, Swan described how a party of Haida in Port Townsend, Washington, allowed him to copy their tattoo marks. He found that the marks were heraldic designs of the family totem, or crests of the wearers. On the men they were positioned between the shoulders just below the back of the neck, on

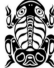

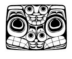
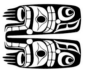

the chest, on the front part of both thighs, and just below the knees. The women were marked on the breast, on both shoulders, on both forearms from the elbow, over the back of the hands to the knuckles, and on both legs below the knee to the ankle.

Today, the Haida are renowned around the world for the beauty and complexity of their art and images, and the bold lines of their designs are uniquely suited to reproduction as tattoos. The Haida were once one of the most heavily tattooed indigenous people in the world, and were one of very few groups in recorded history to tattoo in color, using red as well as black.

Haida crests chronicled important mythological events in the family or clan's history; usually when an ancestor encountered a spiritual being in a supernatural context. Stories related to these events were told and retold, in turn setting the specific family or clan apart from others while defining their social position among Haida society. When tattooed upon the body or carved onto an object, crests served as title to the animal or geographic

> "WITH THE HAIDAS... EVERY MARK HAS ITS MEANING ..."
>
> JAMES SWAN, *TATTOO MARKS OF THE HAIDA*, 1878

Traditional Haida tattoo designs

feature depicted on it, as well as to its spirit. Thus, the right to a crest, the right to use the emblem, was more valuable than the particular physical object itself. Crests were symbols of power and prestige and their owners were given the right to pass them on to their heirs.

The two major Haida clans were raven and eagle, with numerous subsets, symbolized by bear, frog, hummingbird, beaver, otter, wolf, and many others. The powerful animal totems and spirits that surrounded the Haida were also well represented, such as the orca, salmon, thunderbird, and many, many more.

MODERN UNITED STATES

Early records of tattoos in North America are detailed in ships' logs, letters, and diaries written in the early nineteenth century. One of the first professional American tattoo artists was C. H. Fellowes, who was believed to have followed the fleets and practiced his art onboard ship and in various ports.

Several tattoo artists found employment in Washington, DC, during the Civil War. The best-known tattooist of the time was Martin Hildebrandt, who began his career in 1846. He traveled extensively and was welcomed in both the Union and Confederate camps, where he tattooed military insignias and the names of sweethearts. In 1870, Hildebrandt established an "atelier" on Oak Street in New York City; the first American tattoo studio. He worked there for over 20 years and tattooed some of the first completely covered circus attractions, including his daughter.

MECHANICAL ADVANCEMENT

Samuel O'Reilly opened a tattoo studio at 11 Chatham Square, in the Chinatown area of the Bowery in Manhattan in 1875. At this time, tattooing was done by hand. The tattooing instrument used by Hildebrandt, O'Reilly, and their contemporaries was a set of needles attached to a wooden handle. The tattoo artist dipped the needles in ink and moved his hand up and down rhythmically, puncturing the skin two or three times per second. The technique required great manual dexterity and could be perfected only after years of practice. Tattooing by hand was a slow process, even for the most accomplished tattooists.

In addition to being a competent artist, O'Reilly was a mechanic and technician. Early in his career he began tinkering on a machine to speed up the tattooing process. He reasoned that if the needles could be mechanically drawn up and down automatically in a handheld machine, the artist would be able to tattoo as fast as he could draw. In 1891 O'Reilly patented his invention; one that was very similar to a device patented by Thomas Edison for engraving, and offered it for sale along with colors, designs, and other tattoo supplies (see page 18).

Tattooing in the USA was revolutionized within a few short

Barber shop in the Bowery, Lower Manhattan. Photograph taken by Alexander Alland, Sr., c.1940

GROWING POPULARITY

Designs for tattoos were being produced for tattoo artists who didn't draw well—effectively the first flash. When O'Reilly died in 1908, Wagner took over the Chatham Square studio and he patented his own improved electric tattooing machine. Sailors continued to be his customers, and Wagner's business got a boost in 1908 when US Navy officials decreed that "indecent or obscene tattooing is a cause for rejection, but the applicant should be given an opportunity to alter the design, in which case he may, if otherwise qualified, be accepted." When Wagner was interviewed by the newspaper *PM* in 1944, he estimated that next to covering up the names of former sweethearts, the work which brought him the most money over the years had been making sure that recruits complied with the naval order of 1908. During World War II, Wagner was arraigned in New York's Magistrate's Court on a charge of violating the Sanitary Code. He told the judge he was too busy to sterilize his needles because he was doing essential war work: tattooing clothes on naked women so that more men could join the Navy. The judge must

years. O'Reilly was swamped with orders and quickly made a small fortune. He even made housecalls to tattoo wealthy ladies and gentlemen who didn't want to be seen going to his Bowery studio.

O'Reilly took on an apprentice named Charles Wagner, and during the Spanish–American War in 1898, O'Reilly and Wagner worked overtime as sailors lined up to be tattooed with images symbolizing their service in the war. At that time it was thought that over 80 percent of the enlisted men in the US Navy were tattooed.

have felt that this was a reasonable defense. He fined Wagner $10 and told him to clean up his needles.

Wagner was the first American tattoo artist who successfully practiced the cosmetic tattooing of women's lips, cheeks, and eyebrows. He also combined and organized several small designs to make a larger, more harmonious pattern.

Wagner continued to tattoo until the day of his death on January 1, 1953. He was 78 years old and had worked as a professional tattoo artist for more than 60 years. After his death the contents of his studio were hauled off to the city dump. All his original drawings were destroyed. He had tattooed thousands, and hundreds of tattoo artists admired his designs and drew variations from them. Today he is recognized as a major influence in the classic American style of tattooing.

tattoos in the twentieth century

Body ornamentation, especially tattooing, was spread among Western societies when soldiers and sailors returning from conquest and trade imitated the practices they had seen among the indigenous people of Asia, Africa, and the South Pacific. Working class men in Europe and America wore tattoos primarily as a symbol of masculine pride throughout the nineteenth and early twentieth centuries. However, a revival of interest in body modification in Western societies in the late twentieth century is associated more with popular culture than with the foreign origins of such practices.

The beatniks of the 1950s and the hippie movement of the 1960s turned to Asian tattooing techniques as a personal expression of spiritual

Miss Liberty design, unknown artist, 1900s

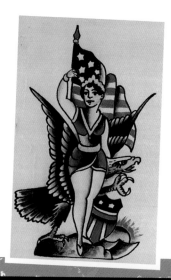

and mystical body estheticism. Conversely, working-class young people of the punk movement in the late 1970s and 1980s used tattoos and piercing as symbols of rebellion in an explicit political protest against their feelings of imprisonment in society's rigid class and value structure.

Tattoos have also been recently linked to the American fine art world in a number of ways. One of the significant ties lies with the profusion of academy-trained artists entering the tattoo profession. One late 1980s estimate placed the number of trained artists per year as having doubled, compared with those who graduated in the 1970s. Even though the number of galleries also grew within that period, art schools and programs were turning out more trained artists than the mainstream art world could absorb. Within this climate it is not surprising that art-school graduates have migrated into the tattoo profession. As a result, the techniques acquired in various art programs influenced the creation of new tattoo styles, such as "new skool" and "bio-mechanical," and inspired a commitment to innovation and experimentation.

While tattoos have long been recognized for their esthetic value within tattoo communities, a defining moment in tattoo art's legitimization process began in 1995, when SoHo's The Drawing Center, a prestigious, nonprofit art institution, presented "Pierced Hearts and True Love: A Century of Drawings for Tattoos." This exhibition of Western tattoo flash and its Asian influences marked the first major New York City tattoo exhibition under the distinguished heading of "art." Flash—drawings of tattoo designs

Tattooing was a major part of the punk esthetic

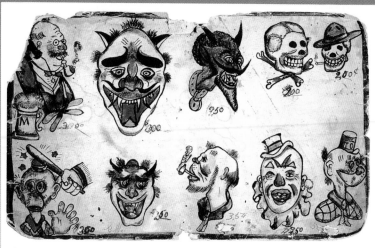

Gus Wagner design, c.1910

commonly found on tattoo studio walls—comes in two varieties: standardized images that are sold commercially, or images drawn by tattoo artists themselves. When displayed within a gallery context, the meanings and functions of the objects depicted in the flash were recognized as having esthetic value.

In 1999, New York City's South Street Seaport Museum hosted an exhibition entitled "American Tattoo: The Art of Gus Wagner," at the same time as the American Museum of Natural History presented "Body Art: Marks of Identity," which prominently included tattooing.

Although these exhibitions differed in content and scope, they shared one essential commonality: the designation of tattoo as art in an ethnographic and historical institutional context. Alan Govenar, tattoo historian, researcher, and collector, described "Body Art" as "a major breakthrough for the museum to show its outstanding collection and to create a context where that work could be understood."

SOUTH AMERICA

When Hernán Cortés and his conquistadors arrived on the coast of Mexico in 1519, they were horrified to discover that the natives not only worshiped devils in the form of statues and idols, but also had somehow managed to imprint indelible images of these idols on their skin. The Spaniards, who had never heard of tattooing, recognized it as the work of Satan.

The sixteenth-century historians who chronicled the adventures of Cortés and his conquistadors reported that tattooing was widely practiced by the natives of Central America and said that the natives "imprinted on their bodies the images of their demons, held and perpetuated in black color for as long as they live, by piercing the flesh and the skin, and fixing in it the cursed figure."

The Spanish invaded Central and South America with a pattern of destruction and genocide. Whenever missionaries encountered tattooing, they eradicated it. The only surviving record of pre-Columbian tattooing is found on sculptures on which tattoos are represented by engraved lines on the bodies of human figures.

No doubt these tattoos had great significance within the context of Central and South American culture, but this information has been lost.

In 1920, archeologists in Peru unearthed tattooed Inca mummies dating from the eleventh century AD. Very little is known about the significance of tattooing within the culture of the Incas, but the elaborate nature of the designs suggests that Inca tattooing underwent a long period of development during the pre-Inca period.

The only indigenous tattooing that still exists in South America is among groups that have managed to avoid contact for as long as possible and remain isolated to this day.

The oldest carbon-dated tattoos originated in the Amazon Basin of South America

ANCIENT EGYPT

Dating to as early as the XI Dynasty (2160–1994 BC), the recovered bodies of ancient Egyptians have been found to exhibit tattoo art forms. The mummy of Amunet, a priestess of the goddess Hathor, found at Thebes, displayed several lines and dots tattooed about her body. Several other female mummies from this period showed similar tattoos, in addition to ornamental scarring—which is still popular today in some parts of Africa—across the lower part of the abdomen. It is believed that the series of dots and dashes held protective and fertility-promoting significance, while the lozenges were connected to the primal female power of the universe, motherhood.

Eye of Horus

The Egyptians may have used tattoos for a number of reasons, such as to connect with the divine; as a tribute or act of sacrifice to a deity; as a talisman, a permanent amulet that cannot be lost; or to provide magical or medical protection. Certainly, the connection between tattoos and the divine existed in ancient Egypt.

The God Bes

Beyond the geometric designs that were favored, other designs were intrinsically connected to religion. For example, mummies dating from roughly 1300 BC were found to have pictograph tattoos symbolizing Neith, a prominent female deity with a militaristic bent.

Typical mummy body art consisted of small decorations in patterns across the lower abdomen and upper thighs. Another mummy also had a cicatrix pattern over her lower pubic region.

THE GOD BES

The earliest known tattoo of a picture of something specific, rather than an abstract pattern, represents the god Bes. Bes was the lascivious god of revelry who served as the patron god of dancing girls and musicians. Bes's image appears as a tattoo on the thighs of dancers and musicians in many Egyptian paintings, and Bes tattoos have been found on female Nubian mummies dating from about 400 BC.

WEST AFRICA

A form of tattooing called cicatrization or scarification has been widely practiced in traditional African societies. Rubbing charcoal into small cuts made with razors or thorns forms decorative patterns of scar tissue in the skin. These designs are often indicative of social rank, traits of character, political status, and religious authority.

For African women, scarification is largely associated with fertility. Scars added at puberty, after the birth of the first child, or following the end of breastfeeding, highlight the bravery of women in enduring the pain of childbirth. Scars on the hips and buttocks, on the other hand, both visually and tactilely accentuate the erotic and sensual aspects of these parts of the female body.

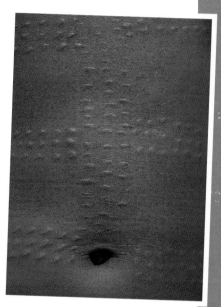

Top: Scarification on a Mursi woman's stomach

Bottom: Tribal markings of the Fulani people of Niger, West Africa

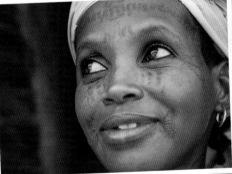

ANCIENT GREECE AND ROME

The ancient Greeks learned tattooing techniques from the Persians, and used tattoos to mark slaves and criminals so they could be identified if they tried to escape. The Romans in turn adopted the practice from the Greeks and, in late antiquity, when the Roman army consisted largely of mercenaries, they were also tattooed so that deserters could be identified.

Many Greek and Roman authors mentioned tattooing as punishment. Plato thought that individuals guilty of sacrilege should be tattooed and banished from the Republic. Suetone, an early writer, reports that the degenerate and sadistic Roman emperor Caligula amused himself by capriciously ordering members of his court to be tattooed. According to the historian Zonare, the Greek emperor Theophilus took revenge on two monks who had publicly criticized him by having 11 verses of obscene iambic pentameter tattooed on their foreheads.

STIGMA

The Latin word for tattoo is *stigma*, and the original meaning is reflected in modern dictionaries, which include the definitions "a prick with a pointed instrument . . . a distinguishing mark . . . cut into the flesh of a slave or a criminal . . . a mark of disgrace or reproach." The oldest known description of tattoo techniques, together with a formula for tattoo ink, is found in *Medicae artis principes* by the sixth-century Roman physician, Aetius. He writes:

> Stigmates are the marks that are made on the face and other parts of the body. We see such marks on the hands of soldiers.

To perform the operation, they used ink made from Egyptian pine wood (acacia), especially the bark; corroded bronze; gall; vitriol; vinegar; and water. The area to be marked was washed with leek juice, and the design pricked with pointed needles until blood was drawn, at which point the ink was rubbed in.

EARLY TATTOO REMOVAL

Because of the disgrace associated with tattooing, Greek and Roman physicians did a brisk business in tattoo removal, and Aetius had a recipe for that. He wrote:

In cases where we wish to remove such tattoos, we must use the following preparations . . . There follow two prescriptions, one involving lime, gypsum and sodium carbonate, the other pepper, rue and honey. When applying first clean the tattoos with nitre, smear them with resin of terebinth, and bandage for five days. On the sixth prick the tattoos with a pin, sponge away the blood, and then spread a little salt on the pricks, then after an interval of stadioi [presumably the time taken to travel this distance], apply the aforesaid prescription and cover it with a linen bandage. Leave it on five days, and on the sixth smear on some of the prescription with a feather. The tattoos are removed in twenty days, without great ulceration and without a scar.

Other Greek and Roman physicians used different special formulas, such as pigeon feces mixed with vinegar and applied as a poultice.

SLAVES AND CHRISTIANITY
During the early Roman Empire, slaves exported to Asia were tattooed "tax paid," and words, acronyms, sentences, and doggerel were inscribed on the bodies of slaves and convicts, both as identification and punishment. A common phrase etched on the forehead of Roman slaves was "Stop me, I'm a runaway."

As Christianity spread throughout the Roman Empire, the tattooing of slaves and criminals was gradually abandoned. The Roman emperor Constantine, who declared Christianity the official religion of the Empire in AD 325, decreed that a man who had been condemned to fight as a gladiator or to work in the mines should be tattooed on the legs or hands, but not on the face, "so that the face, which has been formed in the image of the divine beauty, should be defiled as little as possible."

In AD 787 Pope Hadrian I forbade tattooing of any kind, and the popes who followed him continued this tradition, which explains why tattooing was virtually unknown in the Christian world until the nineteenth century.

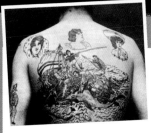

French tattooing, 1900s

Ambitious, full-scale back pieces portrayed scenes from history, mythology, and literature. Lacassagne counted over 30 tattoos featuring the three musketeers, and also popular were portraits of Napoleon, Joan of Arc, Charlotte Corday, Garibaldi, Bismarck, and other historical figures. The most popular mythological figures were Bacchus, Venus, and Apollo.

GERMANY

Germany has a long history of body decoration, and there have been many German attractions in sideshows on both sides of the Atlantic. One of the first professional tattooists in the United States was a German immigrant. His daughter Nora was the first female tattoo attraction in the United States in the 1860s. Nora had separate tattoos for each day of the year. She appeared in Brunnell's Museum in New York City in 1882. During the Holocaust, concentration camp prisoners received tattoos at the Auschwitz camp complex. The camp authorities assigned more than 400,000 prisoner serial numbers (not counting approximately 3,000 numbers given to police prisoners interned at Auschwitz due to overcrowding in jails, who were not included in the daily count of prisoners). European Jews rarely tattooed their bodies, because many felt that it was against their religious teachings and beliefs to mark the skin. This belief made the tattoos associated with the Holocaust an even greater atrocity; one that haunted many survivors for the rest of their lives.

ITALY

The first written account of tattooing among convicts in Italy appeared in Cesare Lombroso's *L'Uomo Deliquente* in 1876. He was a professor of psychiatry and criminal anthropology at the University of Turin. He examined 5,343 criminals and found that about 10 percent of the adults were tattooed. He recommended that when examining a criminal, prison officials should make a detailed record of their tattoos.

THE BRITISH ISLES

The Celts were a tribal people who moved across Western Europe between *c.*1200 and 700 BC. They reached the British Isles around 400 BC, and most of what has survived from their culture is in the areas now known as Ireland, Wales, and Scotland. The Celtic culture celebrated body art, and permanent body painting used woad, which left a blue design on the skin. Spirals were a common motif and appeared single, doubled, or tripled. Knotwork is probably the most recognized form of Celtic art, with lines forming complex braids that weave across themselves. Celtic knots symbolize the connections in life, and the step or key patterns, such as those found in early labyrinth designs, can be seen both in simple borders and full, complex mazes.

The Picts were the tattooed tribal nations of the north of Britain, the area now known as Scotland. In AD 600, Isadore of Seville makes reference to the Picts having taken their name from the fact that their bodies were covered in designs pricked into their skin by needles. The Romans referred to them in Latin as *Pictii*, "the painted ones," in reference to the elaborate tribal tattoos with which the Picts decorated their entire bodies.

RELIGIOUS AND PAGAN TATTOOING

In the fourth century AD, Saint Basil the Great, one of the most distinguished scholars of the Church, admonished the faithful:

> No man shall let his hair grow long or tattoo himself as do the heathen, those apostles of Satan who make themselves

The designs on a Celtic knot are symbolic of the various paths that life's journey can take

despicable by indulging in lewd and lascivious thoughts. Do not associate with those who mark themselves with thorns and needles so that their blood flows to the earth. Guard yourselves against all unchaste persons, so that it cannot be said of you that in your hearts you lie with harlots.

However, an edict issued by the Council of Northumberland in England in AD 787 makes it clear that the Fathers of the Church distinguished between profane tattoos and Christian tattoos. They wrote: "When an individual undergoes the ordeal of tattooing for the sake of God, he is greatly praised. But one who submits himself to be tattooed for superstitious reasons in the manner of the heathens will derive no benefit there from." The heathen tattooing referred to by the Council was the traditional tattooing of the native Britons, which was still practiced at the time.

INSPIRED BY TRAVELS

During the nineteenth century, tattooing flourished in England like nowhere else in Europe. This was due to the tradition of tattooing in the British Navy, which began with the first voyage of Captain Cook in 1769. During the decades that followed, many British seamen returned home bearing souvenirs of their travels in the form of exotic tattoos. Sailors learned the art, and by the middle of the century most British ports had at least one tattoo artist in residence.

Young sailor apprentice having a tattoo. From an image published in 1880, drawn by Davidson Knowles

PROFESSIONAL ARTISTS

The first British professional was D. W. Purdy, who established a shop in North London around 1870; however, one of the most prominent British tattoo artists of the late nineteenth century was Tom Riley. Riley had a natural talent for drawing that he developed while tattooing thousands of regimental crests and other military designs during the South African War and the Sudan Campaign. After leaving the army, Riley established himself as a tattoo artist in London. His cousin, Samuel O'Reilly, was the successful New York tattooist who invented and patented the first electric tattooing machine in 1891 (see pages 18 and 58). Riley's success was not only due to his skill, but also his salesmanship. One of his original publicity stunts was the all-over tattooing of an Indian water buffalo at the Paris Hippodrome in 1904.

Riley's greatest rival was Sutherland Macdonald. Like Reilly, Macdonald learned tattooing while

A tattooist inking a sailor motif on the chest of a Royal Navy sailor, c.1945

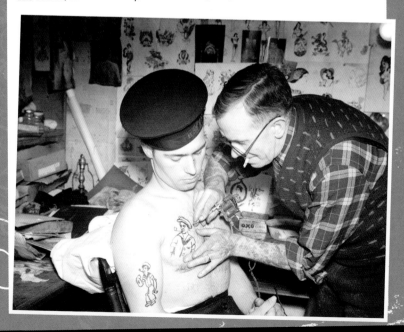

serving in the British Army and later enjoyed the benefit of formal art school training. In 1890 he opened a London studio. He dressed formally and called himself a "tattooist" rather than a "tattooer." Macdonald enjoyed a privileged status with the Royal Navy and he advanced his career by courting journalists to ensure he became the subject of flattering magazine and newspaper articles. In 1897, *Le Temps* reported that he had elevated tattooing to an art form and in 1900 he was referred to in *L'Illustration* as "the Michelangelo of tattooing." Macdonald continued to tattoo until his death in 1937.

George Burchett is considered one of the greatest of the early British tattoo artists. He began his professional career in 1900, when Riley and Macdonald were at the height of their fame. As a child he was fascinated by tattoos, and at 13 he enlisted in the Royal Navy and learned the rudiments of tattoo art. After roaming the world for 12 years, he returned to England. At 28, he opened his first studio and began a career that earned him fame, a small fortune, and the title King of Tattooists.

Burchett is the only British tattoo artist who left a written record of his life and his work. After his death, his friend helped compile and edit his memoirs, diaries, and other materials, and in 1958 a book, *Memoirs of a Tattooist,* was published.

ROYAL APPROVAL

Tattooing gained royal sanction in 1862 when the Prince of Wales visited the Holy Land and had a Jerusalem Cross tattooed on his arm. In later life, as King Edward VII, he acquired a number of traditional tattoos. When his sons, the Duke of Clarence and the Duke of York (later King George V), visited Japan in 1882, Edward VII instructed their tutor to take them to the tattoo master Hori Chiyo, who tattooed designs on their arms. On their way home, the two dukes visited Jerusalem and were tattooed by the same artist who had tattooed their father 20 years before.

Following the example of the dukes, many wealthy Britons and naval officers acquired tattoos from Japanese masters. By 1890 the fad had spread to the U.S., and tattoos were seen on members of the highest social circles.

Sailor being tattooed, c.1940

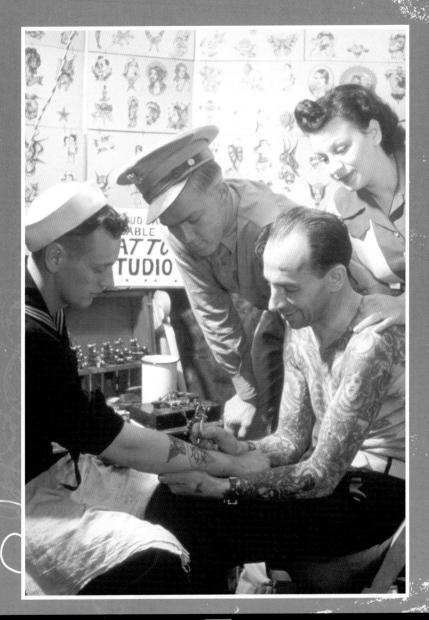

CELTIC FRINGE

Celtic tattoo designs are distinguished by the use of complex interwoven lines representing knots, mazes, spirals, and other figures. Many images used by tattoo artists today are derived from the famous *Book of Kells*, an ornately illustrated manuscript produced by Irish monks around AD 800—one of the most lavishly illuminated manuscripts to survive from that period. The name is derived from the abbey in Kells, County Meath in Ireland, where it was kept for much of the medieval period.

CELTIC KNOTS

There are strong Norse design influences in Celtic knots, and there is some debate as to their exact origin. The complexity of Celtic design is thought to mimic or echo the complexity of nature, and the intricate interweaving of Celtic knots, in spirals and mazes that show no beginning or end, is reflective of the cycles of seasons and of life.

CELTIC CROSS

If you are Irish, Scottish, or Welsh, the Celtic cross, combining cross and circle shapes, may be more symbolic of your ethnic heritage than of your faith. The same is true for other Celts in Brittany, Cornwall, Galicia, and the Isle of Man. If you are Scandinavian you may also be drawn to the Celtic cross, because Norse and Celtic art have heavily influenced each other. This mixing of cultures makes the origin of the Celtic cross debatable, but one explanation is found in the legend of Saint Patrick, who attempted to bring the Christian word to the Druids. The cross as a Christian symbol was just emerging in the fourth century AD, when

the Gospel was being introduced to a sun- and moon-worshiping culture in what is now the British Isles. Shown a sacred standing stone marked with a circle, Patrick blessed it by making the mark of a Latin cross through the circle.

As symbolic expressions, the circle and the cross could not be more different. One is mystical while the other is almost geographical. The circle is a symbol of eternity and the endlessness of God's love, while the cross relates to the four directions or four corners of the earth, and perhaps the four elements. The coming together of the axes implies the joining of forces such as heaven and earth, and enclosing them within the circle suggests a realm where time and space cease to exist, a precondition for communication between this world and the one beyond.

As a tattoo design the Celtic cross may have different meanings for different peoples, but at its symbolic roots it is a design that powerfully evokes the spiritual nature of the universe.

DESIGN DIRECTORY

LOVE NATURE FATE
MUSIC MAGIC ANIMALS
ZODIAC SOLAR SYSTEM
PATRIOTISM ANARCHY
MILITARY HERALDRY DEATH
FAITH AND SPIRITUALITY
MYTHICAL CREATURES
LUCKY TATTOOS
NAUTICAL SCRIPTS

LOVE

The most obvious motif of love is the heart, which can be used in tattoos in various ways. You may also choose to mark the love you have for another with symbols such as wedding rings, lips, or roses. *See also* rose, page 96.

HEARTS

The heart is the eternal symbol of love, romance, and the very life-force within all of humankind. Friendship, courage, romantic bonds, and emotional expression are also embodied in the symbol of the heart. The heart tattoo, shaped like an inverted triangle and meant to symbolize the pubic triangle, is a universal symbol of the feminine, often used as the ultimate expression of romantic love. Heart tattoos with banners were very popular with servicemen in World War II, as tokens of their loved ones that accompanied them on perilous journeys, and a constant reminder of the values they were fighting to protect and preserve. As they say, "love lasts forever. A tattoo lasts six months longer."

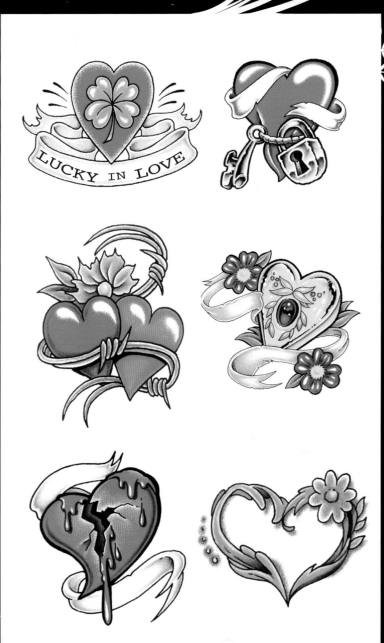

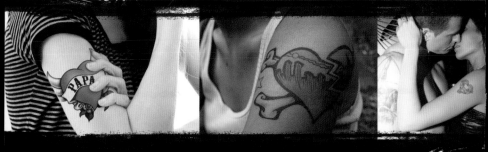

HEART VARIATIONS

PIERCED WITH AN ARROW

The arrow is a symbol for directed energy flow and penetration. When paired with (and piercing) the heart, it represents the not-unpleasant sting of love. The arrow is often delivered by Cupid, the messenger of love.

PIERCED BY A DAGGER

This variation usually represents love betrayed, and is a potent symbol of a broken heart, or a heart in mourning.

BROKEN HEART

A symbol of the loss of love, most often of a spurned or rejected lover, and the pain this has caused the wearer.

HEART-SHAPED FLAGS

This popular variation attests to a great love of your country.

HANDS HOLDING A HEART†
Representative of a more maternal or paternal kind of love, this variation also symbolizes the Claddagh, or the heart given in love; a popular Celtic motif.

GOLDEN HEART†
Popularly associated with self- or god-consciousness, a golden heart symbolizes the personal awareness that you are at one with all things.

BLACK HEART†
A black heart commonly illustrates grief or mourning.

WHITE HEART†
In 1999 the white heart was adopted as the universal symbol of nursing, so it's a great one for healthcare professionals to integrate into their ink.

SACRED HEART†
The sacred heart is a symbol of charity, piety, and understanding; for sorrow, as well as joy and happiness. *See also* daggers and knives, page 175.

CVPİD

In Roman mythology, Cupid is the god of erotic love, and he is equated with the Greek god Eros. In popular culture he is frequently shown shooting his bow to inspire romantic love, often as an icon of Valentine's Day. Although depicted as a cherub—an infant angel—Cupid is not tied to any religion. Cupid is often used in modern tattoos to commemorate true love.

CHERVBS

A cherub, or cherubim, is an angel depicted as an infant or young child, usually male; these supernatural entities are mentioned several times in the Old Testament and the Torah. Historically, winged figures with a human form predate the Bible, going back to Assyrian myths and legends. The winged figures were often sent as messengers or guides. The concept of cherubs as baby angels did not emerge in Western art until the late Renaissance in Italy. Cherubs are often used in modern memorial tattoos to commemorate the loss of a loved one, a child in particular.

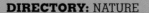

İVY AND VİNES

Ivy and vines feature frequently in tattoo designs, often intertwined with other floral and plant symbols. Because of their shape and form, they can be draped, twisted, and coiled around the human body with ease.

Aside from their natural graphic and design appeal, ivy and vines have a rich symbolic history. Bacchus, the Roman god of wine and revelry, wore a crown of evergreen ivy as a symbol of immortality. A cult of worshipers grew around the god, to celebrate the joys of liberation through intoxication. The revelers often wore the crown of ivy too, believing it complemented or counterbalanced the effects of the grape. Ironically, ivy also stood for intellectual achievement in ancient Rome.

In old Ireland, the Celts regarded the ivy as a symbol of determination, death, and spiritual growth. When portrayed spiraling around a tree it represented rebirth, joy, and exhilaration. The power of the ivy to cling, bind, and even kill the mighty oak impressed the ancient Druids. In respect of ivy's strength, they and other pagan cultures used it in sacred rituals.

As an evergreen plant, ivy became a symbol of everlasting life. Christian artists saw the ivy's spiraling growth as a symbol of the Resurrection. It represented the ascension of the spirit to the divine. Earlier, the Christian church had rejected both the ivy and the vine as pagan symbols, because they were being used in the Roman celebrations of winter, during which the god's staff was made of holly and his sacred bird was said to nest in

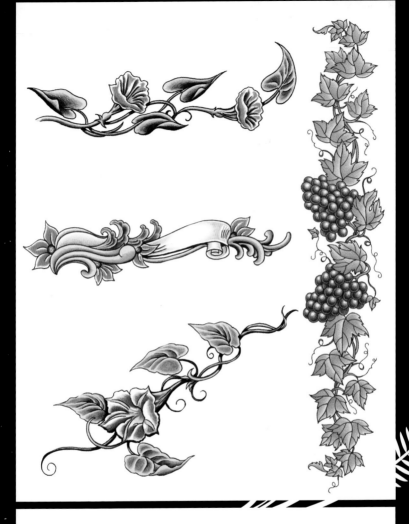

ivy. Centuries later, the holly and the ivy became inseparable as Christmas plants, their pagan connections forgotten.

In times past, lovers took ivy to be a symbol of their fidelity. Brides carried it in their wedding bouquets, while women wore it for fertility and good luck. In Victorian times the plant was a symbol of wedded love and friendship in matrimony.

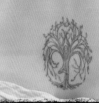

✝REES

Trees are powerful symbols of regeneration and rejuvenation; vivid reminders to us of the seasons and the cycle of life. In a number of Asian and African cultures, the creation myths tell stories of men hanging from trees like fruit until they were plucked and came to life. Buddha found enlightenment in his long meditation under the branches of the bodhi tree, and the Celts believed that trees had spirits and were living beings. Celtic art often represented the branches and roots of trees as intertwined; a potent symbol of the interconnectedness of the conscious and unconscious worlds.

FLOWERS

Flowers are the embodiment of nature and symbols of the cycle of birth, life, procreation, death, and rebirth. Their color, shape, scent, and unique characteristics have given rise to myriad myths and characters whose names were synonymous with the flowers themselves. Specific flowers have come to represent different beliefs in different cultures. In the East, the lotus flower has tremendous spiritual significance, as does the rose in the West; with Buddha represented by the lotus, Christ by the Rose. The spectrum of colors present in flowers can have symbolic importance, such as white for purity and red for passion or to represent the blood of Christ.

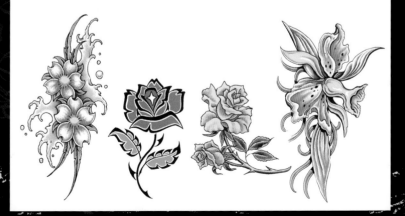

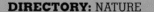

LİLİES & LOTVSES

While its long white petals speak of purity, innocence, and chastity, at the same time the lily's form has evoked associations of erotic love and procreation. Liturgically, the lily is a symbol of Easter and Christ, resurrection and immortality. The lotus is as symbolically important in the east as the rose is in the west. It figures prominently in the Creation Myths of India and China, and Buddha is said to have risen at the center of a lotus blossom. The lotus flower is symbolic of rebirth, but in addition to its religious meaning, it also represents all that is true, good and beautiful, symbolizing good fortune, peace and enlightenment.

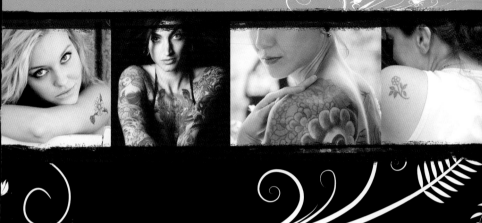

PEOΠİES & DAİSİES

Flower symbolism was especially important to medieval and Renaissance artists, and every flower had a very specific meaning. The white daisy, one of the simplest and most abundant blossoms to be found in every meadow and glade, was a symbol of innocence. By the late fifteenth century the daisy had become a symbol of the innocence of the Christ child. The daisy, less exotic and pretentious than the lily, was thought by some to be a more fitting symbol for the baby Jesus. Since then, daisies have been associated with children and the innocence of childhood. For young women, a bouquet of daisies denoted a particularly innocent, pure, and chaste expression of love.

STRAWBERRIES

A symbol for Venus in Ancient Rome because of its bright red color and heartlike shape; it is said that two people who share a double strawberry are destined to fall in love. During the fifteenth century, monks of Western Europe began to illustrate manuscripts with depictions of the Madonna and child, or the Virgin Mary. Wild strawberries were often included in the margins or in the illustrations themselves beacause the leaves of the strawberry plant are triumvirate, and thus a reminder of the Holy Trinity. The strawberry came to symbolize perfection of spirit, peace, and the feminine ideal. Today a luscious, ripe, red strawberry is a symbol of fertility, temptation, and passion.

CHERRIES

In China cherry blossom is a prominent cultural symbol, and in Japan it has come to represent the Samurai class. The juice of a ripe cherry is both intensely flavored and strongly colored, and it has often been compared to the first taste of love. There has also long been an erotic connection to the fruit of the cherry tree; cherries are said to resemble a lover's lips, and when you bite into a cherry, the fruit gives the appearance of bleeding. As a tattoo symbol, the cherry ripening on the tree has come to represent feminine chastity and purity. A cherry surrounded by flames speaks of unquenchable desire, passion, and lust.

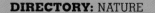

THE ROSE

Of all the flower tattoo designs, the rose is the most requested. Interestingly, it is nearly as popular with men as it is with women.

In the West the rose represents love, but especially a love that is pure. Symbolic of passion, chastity, and purity, the rose reigns supreme as the most beloved of flowers.

The rose's beauty, variety, and exquisite scent have been an inspiration to humankind from the time it was first encountered. For the ancient Romans and Greeks, roses represented beauty and love, and it is said that Cleopatra had her palace strewn with rose petals to receive her lover, Mark Anthony. Diana, the Roman goddess, in a fit of jealousy, turned the maiden Rhodanthe into a rose, and her suitors into thorns.

Early Christians associated the rose with their Roman enemies, hence it became a mark of scorn, but eventually it came to symbolize the survival of persecution. Later yet, won over by its fabulous beauty, Christians adopted the rose as a symbol of the miraculous. At least a dozen saints have their names linked with roses, and the Virgin Mary herself is called "The Mystical Rose." The first "rosary" is said to have consisted of roses then, later, rose-carved beads.

Countless tales and legends name the rose as a source of love and delight. According to the ancient Persians, the nightingale loved the white rose so much that the bird embraced it, piercing its heart and turning the rose

SIGNIFICANCE OF COLOR

A rose's color has its own symbolism. Yellow roses are for joy, white for reverence, light pink for sympathy and admiration, and orange for enthusiasm. In medieval times the white rose was the symbol of virginity. Red covers every kind of love, both sacred and romantic.

ROSE WITH THORNS

A tattoo of a rose with prominent thorns reminds us that beauty does not come without sacrifice, and that caution must be exercised, lest the prick of the thorn draws blood. Love is not without risk. Ecstasy does not come without its share of agony. The thorny rose tattoo is a perfect symbol with which to remind people of these things.

Ancient Hindu writings speak of the goddess Lakshmi being born of 108 large rose petals, and 1,108 smaller ones. In the fifteenth century in England, during the bloody War of the Roses, the red rose stood for the House of Lancaster, while the white rose represented the House of York.

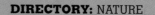

WATER

Asian tattooing often features water and waves as a motif and, traditionally among the Polynesians, water and waves form a strong graphic element among tattoo designs. In China and Japan, koi or carp are representative water symbols. Water as an element is thought to represent the feminine, and is seen as a powerful force for change. It has the power to abolish, dissolve, purify, wash away, and regenerate. Water is also associated with the principle of moisture and the circulatory movement of blood in animals or sap in plants. It is also associated with the water of the womb and the water of the ocean; both of which signify the beginning of human life. In Western astrology, Pisces, Aquarius and Cancer are said to be water signs. *See also* dragons, pages 196–9; koi, pages 110 and nautical, pages 204–13.

FİRE

The power of fire is both feared and revered. Man's control and use of fire is a singular representation of civilization. To Hindus, fire is one of five sacred elements of which all living creatures are comprised. In Christianity, fire is a symbol of the Holy Ghost and is often used in descriptions of hell; in Judaism candles are lit to usher in holidays and separate Shabbat from the rest of the week, as well as to remember the dead. For the mythological phoenix, the flames that consume it and through which it is reincarnated are symbolic of transformation and rebirth. Fire tattoos may represent transformation, destruction, passion, or light, and serve as a warning to the wearer. Depicted in torches, beacons, urns, and candles; fire represents hope, light, and knowledge.

DĬCE

As tattoo designs, dice are metaphors for life, because as players we can no more determine or predict the numbers that will turn up on a pair of thrown dice than we can predict the future in a capricious universe. Sometimes in life, as in games of chance, it is more important to be lucky than to be talented. Although sometimes referred to as a lucky symbol, or one of good fortune, dice are often featured in tattoo designs that highlight the perils of gambling; sometimes in combination with other vices, including playing cards, drugs and alcohol, guns, racehorses, and women of no virtue.

EIGHT BALL

The eight ball is symbolic of the capriciousness of fate. Some individuals see the eight ball as lucky, if controlled. It is a tattoo design that hints at danger, living on the edge, and casting your fortune upon the winds of fate. For hot-rodders, or those who build and race customized cars, it is common to hang a pair of dice from the rearview mirror and for the shifter knob on the transmission gear shift to be an eight ball. Once again, in this instance the eight ball symbolizes risk, the willingness to take a chance, and the possibility of good luck or misfortune.

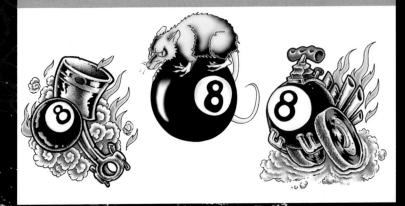

MUSICAL MOTIFS

Tattoo designs symbolizing music can be as obvious as musical notes, treble clefs, and actual measures of music, although instruments, birds, and just about anything that your imagination can conjure up make up musical motifs. Flaming guitars and drums have always been popular with the rock and roll crowd.

In times and places without literature, or an educated audience, musicians had a rich repertoire of songs and stories that told the histories of their peoples and cultures. A musician's life has never been an easy one, but it has long symbolized freedom and a love of music, poetry, and the romance and adventure of the open road.

MUSICAL NOTES
The notational symbols in a measure of music represent the duration of a sound and, when placed on a musical stave—the five horizontal lines—the pitch of the sound. Pitch defines the tone of a note of music in relation to others, thus giving it a sense of being high or low. Musical notes can be full notes, half notes, quarter notes, eighth notes, or sixteenth notes.

GUITARS
The acoustic guitar has a flat-backed, rounded body that narrows in the middle; a long fretted neck; and usually six strings played by strumming

or plucking. The body of an acoustic guitar is hollow and reverberations of sound are produced when the strings vibrate. An electric guitar usually has a solid body with a device known as a pickup—a magnet surrounded by wire—that picks up the vibrations of the guitar strings and sends them to an amplifier, then to the speakers where they are converted into sound.

A guitar tattoo is a favorite among musicians, with electric guitar designs far outnumbering their acoustic brethren. Electric guitars tend to be popular with rock musicians; acoustic guitars with country and western enthusiasts, classical musicians, and lovers of folk music and flamenco.

Similar in nature but with very different sounds, are the lute and banjo. These instruments speak to the long and romantic history of troubadours and musicians, who often lived a nomadic existence traveling between country and market fairs all over the world, when not performing in the courts of the nobility or the taverns and meeting places of the common people.

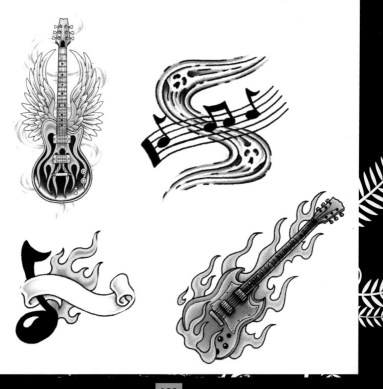

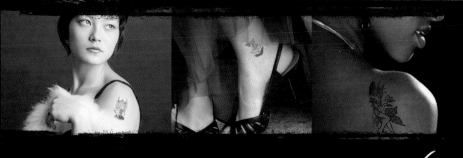

ELVES

Elves are the magical people of Teutonic legend and, according to German mythology, a type of fairy who lived in forests, sometimes in the sea, and even in the air. From Shakespeare's Puck in *A Midsummer Night's Dream* to Tolkien's *Lord of the Rings*, elves have been staple characters for writers and fabulous manifestations in art. Although they were often mischief-makers, elves weren't associated with darkness like trolls and goblins; they belonged to the realm of light. Although not considered divine, elves were thought to be servants of gods and bearers of light. Commonly associated with fertility rites, elves also became the epitome of mischievousness.

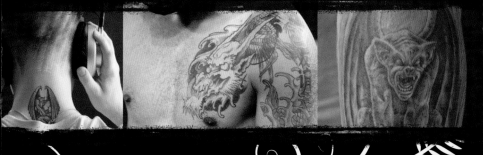

ꝼROLLS & GARGOYLES

Like the evil spirits or demons of many other cultures, Scandinavian trolls represent the capriciousness of nature, the unknown, and the uncertainty of life. Gargoyles, the waterspouts with the not-so-cuddly faces, are increasingly popular as tattoo designs. Both figures are meant to act as amulets and talismans of protection against the unexpected.

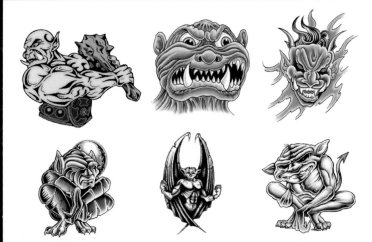

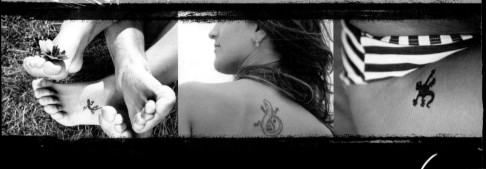

GECKOS

The gecko (a type of lizard) often appears in Polynesian tribal tattoos, since it is said to have supernatural powers, and is regarded by Polynesians with fear and awe. It is rumored that if a green gecko "laughs" at you it is a terrible omen of illness and bad fortune.

Just as the lizard is able to drop its tail in order to escape danger, so the lizard totem shows us the principles of self-protection.

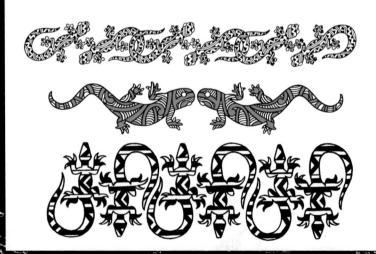

FROGS

The frog as a tattoo design cuts across many cultures. It is associated with the ability to jump from one state of consciousness to another, and is a symbol of generation, rebirth, and fertility. Within the animal kingdom, the frog is seen as a teacher. A cold-blooded creature, the frog possesses an extremely sensitive skin which shamans consider magical.

SHARKS

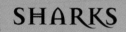

In the West the shark is viewed as the world's greatest predator, and a tattoo of one is a symbol of power and fearlessness. Among sailors, a shark tattoo is considered protective. Many indigenous peoples around the world see the shark more positively than the man-eating machine depicted in the movie *Jaws*. It's a sacred animal, and its power and strength are more revered than feared. The totems of some Native Americans use it as a symbol of the hunter. In Australia the shark is regarded with the same awe and respect that Westerners afford the eagle or lion. Polynesians considered the shark to be a sacred animal, and a shark tattoo protected them from their enemies.

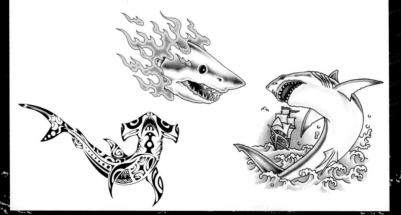

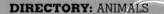

DOLPHİNS

Dolphins were revered among the sailors of ancient Greece and Rome as symbols of divine protection and guidance. It was thought they would help lost sailors back to their home ports and rescue those who fell overboard. They were seen as messengers for the gods, and killing one was punishable by death. The Celts associated the dolphin with the healing power of water, while some Australian aboriginal tribes claim to be direct descendants of dolphins, sometimes regarded as guardian spirits. The dolphin also represents diligence, salvation, charity, and love.

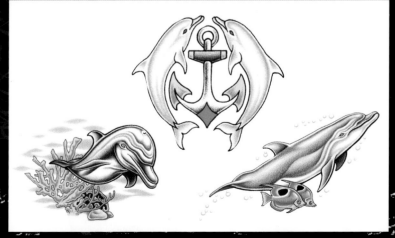

KOI

Koi (Japanese for "carp") are a fixture of Japanese tattooing and feature in both Chinese and Japanese fables. In many stories, they are transformed through their efforts. As a symbol they represent strength of character or purpose. The carp can also represent wisdom, knowledge, and loyalty. In tattoo imagery, especially in combination with flowing water, the carp symbolizes courage, achievement, and overcoming life's obstacles. A koi's age is determined by the rings on its scales. One female koi in Japan is reported to have lived to 226; the koi's longevity has come to symbolize perseverance. Koi tattoos are popular where masculinity is valued. In Japan, the koi would appear on a young man's forearm or leg. As he continued his life's journey he might eventually earn a dragon for his final back piece, echoing the legend of a leaping koi transforming into a dragon at Dragon Gate on the Yellow River. Coloring, whiskers, scaling, and special marks represent a range of qualities a young man might wish for. For personal greatness and national pride, a white koi with a single red spot on the head would be the chosen design.

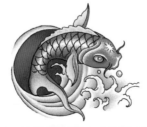
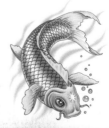

insects

Insects are the most diverse group of creatures on Earth, numbering well over 800,000 species and ranging from the horribly disgusting to the breathtakingly beautiful. From simple outlines to intricate shading, filling, and design, insect tattoos really run the full gamut of tattoo genres. They captivate our attention in part because most of us have an instinctual aversion to insects, and it surprises us to see them decorating human flesh so comfortably. The single most popular specific insect tattoo design is the butterfly; often the first choice of women when getting a tattoo. Other insects have long been popular in traditional tattoo designs among the world's many indigenous peoples, symbolizing as they do myths and stories going back to the dawn of time, in which insects are often the servants or messengers of gods, or gods and goddesses in disguise.

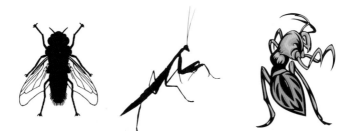

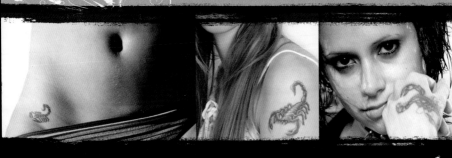

SCORPIONS

Scorpions are popular in Africa, the Middle East, and Southeast Asia. In most cases, scorpion tattoos are potent amulets, meant to protect the bearer from evil spirits. The sting in a scorpion's tail has led to it becoming an emblem of treachery, death, danger, pain, wickedness, and envy; but praying to the Egyptian scorpion goddess was said to ease the pain of childbirth, as the creature acts as a symbol of maternal self-sacrifice. *See also* The Greek Zodiac: Scorpio, page 156.

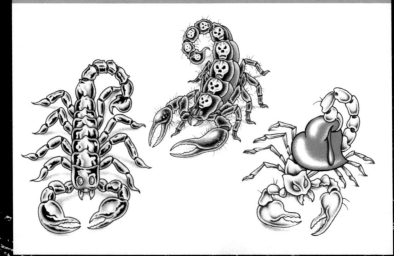

SCARAB BEETLES

Scarab, or dung, beetles, are symbols of the cycle and power of the sun and resurrection. They are lucky amulets for protection and will help guide one successfully into the afterlife. These beetles were often shown with falcons' wings, and these special scarabs ensured that an individual would be able to persuade Osiris to let them into the afterlife regardless of what they might have done that was less than virtuous in life. So a similar tattoo is like a "get out of jail free" card when it comes to the hereafter.

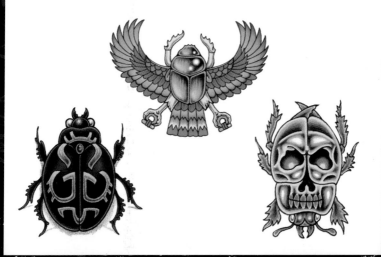

SPIDERS

Spiders generally have a negative reputation in Europe; a hangover from the days of the plague when they were thought to have spread the disease. If you hail from bonny Scotland, however, you will know about Robert the Bruce and the spider. This legendary king of Scotland took refuge in a cave after being defeated in battle by the English. Seeing no hope of recovering his kingdom, he was prepared to leave the country and never return. In his despondence, he watched a spider at the cave entrance building its web, failing over and over again. But the spider did not give up. It eventually completed its web, inspiring the king to fight on. The spider is also a symbol of fertility and harmony. It is often personified as a grandmother, teacher and protector of wisdom. When found dangling at the end of its thread, it is seen as a symbol of luck, because it is thought to be bringing down joy from heaven. The spider has achieved special status within prison and gang tattooing, where webs give information about the length of a prisoner's sentence and the nature of their crimes.

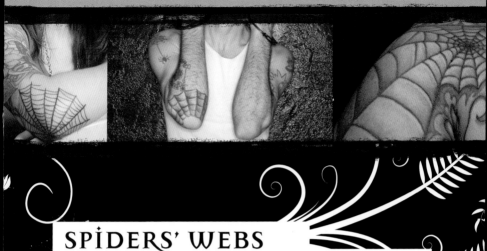

SPIDERS' WEBS

A spider's web tattoo symbolizes struggle and capture, and the multiple strands of the web itself are often a metaphor for bars. You might spot one on an elbow, back, on the side of the neck, emerging from behind the ear and, more rarely, on the face. A more philosophical prisoner might use the spider's web as a reminder that they aspire to escape the web in which they have become entangled. For those with a unique sense of humor, the spider's web can be taken almost as a joke, a statement to the world that the wearer has been locked up for so long he's got cobwebs. Traditionally associated with racists and other antisocial elements, the tattoo in general has become more mainstream, and the web has taken on different meanings. Prisoners, bikers, gang members, and ex-cons must be dismayed to see the web coopted by members of the middle class. Like Gap and Nike, the "gangsta" ethos is a brand many youth want to wear. Rapper Vanilla Ice (Robert Van Winkle) is one rapper among many who sport the spider's web.

LADYBUGS

European folklore states that during the Middle Ages insects were destroying the crops, so the Catholic farmers prayed to the Virgin Mary for help. Soon the ladybugs came, ate the plant-destroying pests, and saved the crops. The farmers began calling the ladybugs "the beetles of Our Lady," and they eventually became known as "Lady beetles." The red wings represented the Virgin's cloak, and the black spots symbolized her joys and sorrows.

DRAGONFLIES

Although not exclusively feminine, the dragonfly, like the fairy and the butterfly, is an extremely popular tattoo design for women. The design can be a small, sexy secret or a large tribute to a wild and free spirit. Symbolically, the dragonfly inhabits two realms, air and water, and passes the influence of both elements to the wearer. The dragonfly spirit is the essence of the winds of change; messages of wisdom and enlightenment; and communication with the elemental world.

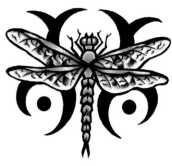

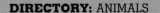

BUTTERFLIES

Delightful, magical, and transformational, the butterfly reminds its admirers of the mystery of nature and the richness of human imagination. Its physical beauty and the way in which it flutters from flower to flower, seeking nectar, have made it synonymous with the more unstable and superficial aspects of the human soul and, because of its short lifespan, many ancient peoples saw it as emblematic of the impermanent.

The butterfly also signifies the airborne soul, because when the caterpillar emerges from its cocoon it is transformed from an earthbound to an aerial entity. In Greek mythology, Psyche was represented in art with butterfly wings, and the ancient Greeks also believed that a human soul emerged each time a butterfly came out of its cocoon. Diverse cultures looked upon the butterfly as a symbol of transformation, regeneration, and flight. Souls were carried by the butterfly from Earth to heaven, or in some cases were believed to be the souls themselves returning to Earth.

Butterfly goddesses have emerged in places as far apart as Minoan Crete and Toltec Mexico. Some of these deities were believed to be the personification of certain butterflies, and were regarded as symbols of beauty, love, flowers, and the spirits of the dead. They were also looked upon as the patrons of women who died in childbirth and warriors who fell in battle.

In Japan, the butterfly spreading its brand new wings after its long spell in the cocoon is a popular symbol for young girls. It represents emerging

beauty and grace, with the added notice to regard change as joyful, not traumatic. Likewise, the Native American peoples honor the butterfly as an emblem of guidance in change. In China, it is still a popular symbol of marital bliss and conjugal harmony.

Although popular with women, the butterfly as a symbol is not entirely the domain of the feminine. One of the butterfly deities of ancient Mexico was the goddess of war and human sacrifice, while the Roman emperor Augustus took it as his personal symbol, and the warrior priests of the Mexican Popolucas peoples sported the butterfly as a motif on their breastplates.

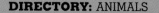

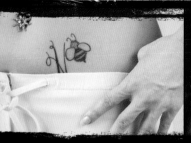

BEES AND WASPS

Archaeological evidence dating back at least 10,000 years shows that early humans gathered honeycombs for the sweet treasure they contained, and there is even a possibility that Neanderthals practiced a primitive form of bee-keeping. In North America, native people revered the bear for its ability to track honeybees back to their hives, and felt a special kinship with the bear because of their shared affinity for the "sweet" life. There are many historical accounts of bees and wasps being employed as ammunition in warfare. The ancient Mayans threw hives of wasps and yellowjackets at attacking tribes, as did the Romans and Greeks, who even catapulted them onto enemy ships. But while their hives were treated as weapons, honey from the bee was used in the healing and treatment of the wounded.

Bees hibernate in the hive during winter, but ancient peoples believed that they died and were reborn in spring, and so they became symbolic of death and rebirth. Because of their ability to find their way home over great distances, bees also came to represent the soul. In Ireland, honey wine was thought to be the drink of immortality, and consequently bees were protected by law. In England, however, an old superstition encouraged people to kill the first wasp of the season, an act that was said to protect you from your enemies; for that month, at least.

It's no surprise that the bee has been held up as a symbol of social order, diligence, and cleanliness. We've all seen how they work incessantly among

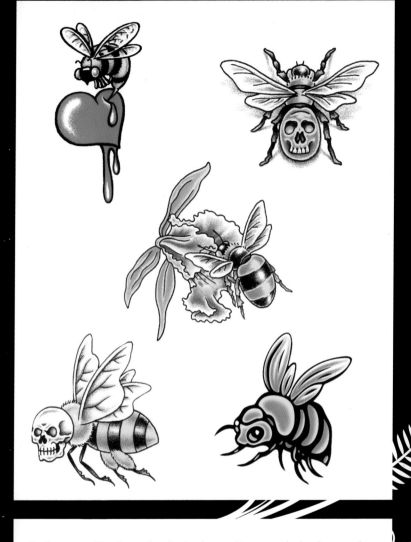

the flowers, pollinating and gathering honey. For many, the bee became the symbol of good, and because of its untiring work, Christians adopted it as the symbol of hope. In France, it was recognized as the regal symbol, and Napoleon had golden bees sewn into his coronation robe. The bee also came to symbolize family and government.

BIRDS

Birds, real and fabled, have been popular tattoo designs for over a hundred years, and they serve as powerful metaphors for our moods and phases of life. All over the world, birds have been chosen to represent the widest range of human emotions, and the stories and myths of many countries and cultures feature birds in central roles. However, not all cultures agree on a bird's symbology. The raven, with its lustrous black feathers, is a sacred bird in many Native American myths. It is both a trickster and a hero, and is often associated with shamans and medicine men. In the Bible, however, this carrion creature is a symbol of evil. In the Middle East, too, the raven is a bad omen.

The most revered aspect of the bird is its ability to fly (apologies to the ostrich, emu, and penguin), and flight through the ages has been symbolic of the soul's journey to the afterlife. A bird in flight also stands for the light of the spirit, for beauty, transcendence, and hope.

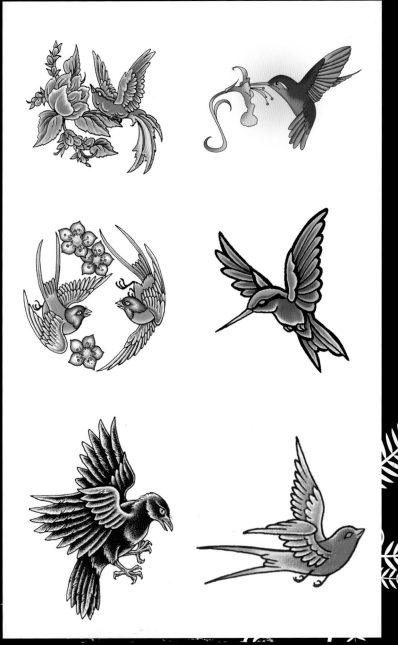

CROSSOVER OF SWALLOWS AND BLUEBIRDS
Occassionally mistaken for the bluebird, the swallow as a nautical tattoo design is a symbol of good luck. The two very different species of bird, the barn swallow and the eastern bluebird, have quite similar coloring, with bright accents of blue and orange, verging on both red and yellow.

BLUEBIRDS

In mythology, the bluebird is the universally acknowledged sign of happiness, prosperity, good health, and the arrival of spring. The beautiful blue of its plumage is associated with the sky and eternal happiness. It also represents confidence and, in the Valentine myth, symbolizes happy love. A dead bluebird is associated with loss of innocence and disillusionment.

SWALLOWS

The swallow heralds the coming of spring and happiness, and is thus a symbol of hope. For some it is a symbol of fertility and renewal, a harbinger of good, and a symbol of transformation. For the pilgrim to Mecca, the swallow is the symbol of constancy and faith. Swallows mate for life, and therefore represent fidelity and loyalty, but in Japan, they can also represent betrayal. In China, the swallow symbolizes daring, danger, and a change for good in the future. For more than a century, the swallow has been a favorite tattoo motif for sailors, because a swallow at sea is usually a sign that land is near. A swallow with a dagger through its heart is a memorial for a friend lost at sea.

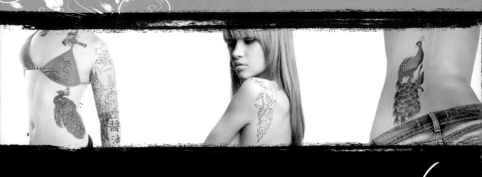

PEACOCKS

Pride, vanity, and strutting arrogance are the qualities we immediately attribute to the peacock. But its beauty and magnificent plumage have gained it a symbolic presence in temples and royal gardens. Sufi legend describes the creation of all living creatures from droplets of sweat from the body of the peacock, while in China, the peacock represents divinity, rank, power, and beauty. The "eyes" of the peacock feather became a favorite metaphor for omniscient witnesses to hidden transgressions. The peacock is the symbol of India, perhaps because it is said to be a great snake-slayer. Immune to snakebites, its venom-rich blood was believed to chase away evil spirits.

CRANES

In Japan after World War II, origami cranes became a symbol of peace and hope. The crane's wingspan of more than 6 ft (1.8 m) has inspired tales of protecting the vulnerable with its embrace, and carrying people to higher spiritual grounds: It was thought that the powerful wings could transport the souls of the newly departed to paradise. Renowned for its spectacular mating dance, the crane has come to symbolize love and joy in relationships, and its fidelity is an inspiration to lovers. According to Native American lore, the crane is a symbol of solitude and independence, although it is actually a gregarious bird by nature, often nesting in large rookeries.

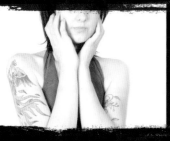
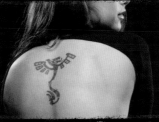
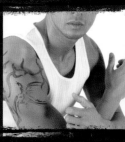

PHOEПİX

Tales of the phoenix appear in ancient Arabian, Greek, Roman, and Far Eastern mythology. In both Greek and Egyptian tales, the phoenix represented the sun, dying in flames at the end of the day and rising each morning. Early Christians came to view the flight of the phoenix as a symbol of rebirth and resurrection, leaving the old world for the new world of the spirit, dying and rising again. It symbolized the victory of life over death, immortality, and Christ's resurrection.

The phoenix is said to live for 500 years. When it grows tired, it builds a nest of aromatic twigs, and then sets fire to itself to be consumed in the funeral pyre of its own making. After three days, the phoenix arises from the ashes, reborn.

According to Chinese mythology, the phoenix is the symbol of grace and virtue and is second only in importance to the Dragon. It represents the union of yin and yang, and was a gentle creature associated with the Empress, who alone could wear its symbol. The phoenix as a tattoo symbol is often associated with feminine qualities, each part of its body representing a specific virtue. Duty, goodness, kindness and reliability are some of the lesser known aspects of the phoenix. The flame images represent purification and transformation through fire and adversity.

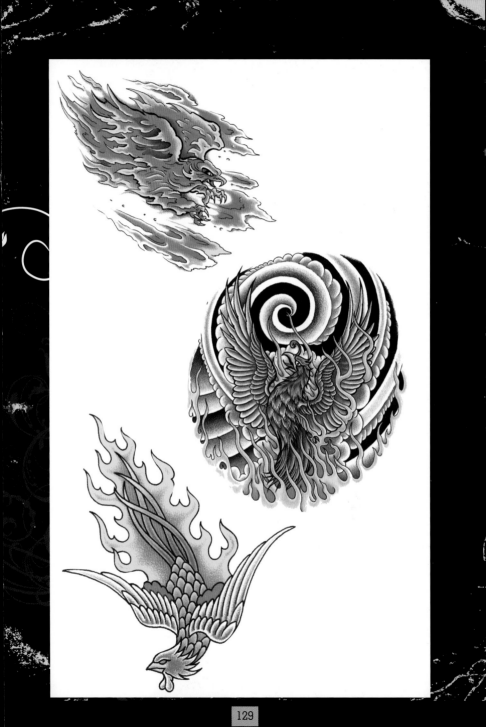

OWLS

Greek, Roman, and Celtic mythology all feature owls as representatives of spiritual influence. The Cree believed that the whistle of the boreal owl was a call to the spirit world; if an Apache dreamed of an owl, it meant that death was imminent. Cherokee shamans looked to eastern screech owls for guidance on punishment and sickness.

To the Bantu people of Africa the owl is the associate of wizards. In eastern Africa, the Swahili believe that the owl brings illness to children. Zulus in southern Africa view the owl as a bird of sorcerers, and in the west of Africa the bird is considered a messenger of wizards and witches. In Madagascar owls are said to gather with witches and dance on the graves of the dead.

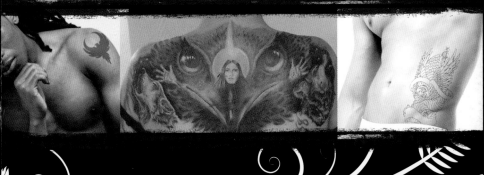

EAGLES

The eagle is an ancient solar symbol. For freedom lovers everywhere, its ability to fly to the tops of mountains and swoop silently into valleys makes it the unchallenged symbol of a free spirit. Kings and emperors have long included it on their coat of arms as the symbol of power. Aztec warriors drew strength from the most powerful bird in the heavens, while their emperor dressed himself in its feathers. In old Mexico, the Eagle was the god of vegetation. It was the symbol of John the Evangelist, a metaphor for vigilance and alertness, and was therefore adopted by the Crusaders as a Christian symbol of the victory of light over darkness. In more recent European wars, the Teutonic Eagle was the fearful emblem of Nazi Germany.

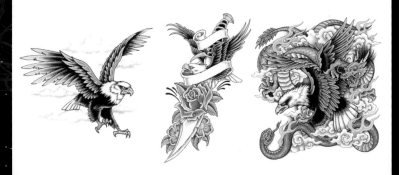

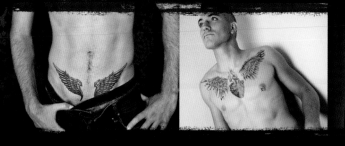

WINGS

Wings as a tattoo design can often have inspirational or spiritual symbolism. Wings associated with birds represent speed, elevation, freedom, and aspiration. Wings associated with angels are spiritual, symbolizing enlightenment, guidance, protection, and inspiration. Wings associated with butterflies, dragonflies, fairies, and mythological creatures have an element of the magical about them. As in alchemy and magic, wings can be transformational, allowing an individual access to a hitherto unattainable state.

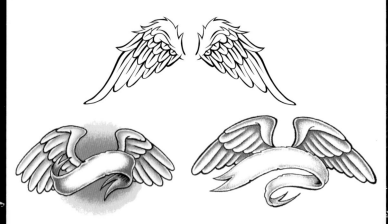

FEATHERS

A single feather as a tattoo design may represent or symbolize the ability to take flight—spiritually, emotionally, or creatively. Many Native American cultures held eagle feathers as sacred because they helped guide prayers and wishes to their intended recipients. Some feathers are so distinctive in their shape and size that they are easily identified with a specific species of bird, such as the feathers of the eagle, peacock, ostrich and egret. Such a feather would represent the characteristics attributed to that bird.

133

FOO DOGS

Also known as lion dogs, celestial dogs, and the lions of Buddha, foo dogs are the statues, lion- and dog-like in appearance, that were believed to guard Buddhist temples more than 2,000 years ago. Once the guardian at the gates of the aristocracy, the foo dog today guards more modest abodes and is often referred to as the dog of happiness. It represents the characteristics and virtues associated with the lion, including strength, authority, nobility of character, pride and justice, and protection. Where it appears in tattoo designs today, it combines both lion and dog features, and is likely to be spotted with claws out and teeth showing, stalking imaginary demons.

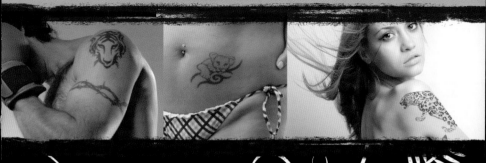

JAGUARS

The jaguar is an ancient totem animal and was a symbol of the nobility of ancient South American royal families. The fur, claws, and teeth of the jaguar were used to adorn the finery of the highest-ranking individuals. It was considered important that the jaguar was equally at home hunting on land or in the water, at night, or in daylight. In South America and Mesoamerica it is a potent symbol of prowess in hunting or battle. The jaguar was a god of the underworld and the symbol of shamans, people who could bridge the conscious and unconscious worlds, and who had access to the spirit world. Many thought the jaguar was a shape-shifter, able to transform itself at will.

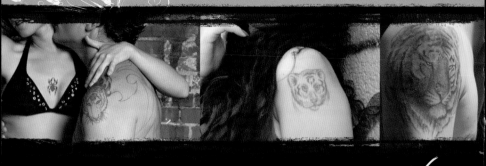

TIGERS

The tiger has long been a fixture in indigenous tattooing in India, Burma, Thailand, Cambodia, Indonesia, Malaysia, China, and Japan. Tigers are associated with power, ferocity, passion, sensuality, beauty, speed, cruelty, and wrath. In Asia the tiger is associated with power, strength, and the might of kings, a position similar to that of the lion in the Middle East and Europe. It can be a symbol of both life and death, as well as evil and evil's senseless or destructive power. In China, tiger images are used as charms to ward off evil, and stone tigers are common protective guards outside buildings and houses. In some areas tigers are thought to punish sinners, in the name of a supreme being, by attacking them. *See also* Chinese zodiac: tiger, page 149.

LEOPARDS

Powerful, graceful, nocturnal, and elusive, the leopard is a master of stealth and survival, renowned for its strength. Wherever it appears on the Earth, its power, strength, and grace is viewed with fear and wonder, and from the earliest civilizations, the leopard has appeared in legends and myths as a creature representing evil or the sacred. A leopard tattoo makes a strong masculine statement; one that symbolizes strength, speed, courage, and endurance. The strength and power of the African leopard represents the masculine qualities of the hunter.

LiOnS

The lion is an ancient symbol, one that has been incorporated into the religion and mythology of numerous cultures and civilizations around the Middle East, India, throughout Africa, and bordering the Mediterranean. The influence of the lion's symbolism can be seen in its representation in both Chinese and Japanese art and mythology.

The lion symbolizes divine and solar power, royal authority, victory, fortitude, pride, nobility, cunning, strength, courage, justice and protection. A lion tattoo may represent some aspects of these qualities to its wearer, and the lion is seen as a powerful guardian figure and protector.

In African cultures the lion was a powerful symbol in many creation myths, as both creator and destroyer, and in some cultures it figured prominently in rites of passages to becoming a man and fully-fledged warrior. To kill a lion single-handedly was the height of prowess for a hunter. However, in many African fables the lion is depicted as a vain, arrogant creature that is outwitted by smaller, more clever creatures, such as mice and monkeys.

The lion has often been used as a symbol of royalty, because in many cultures it was considered the king of the beasts. In early Christianity, because Jesus was seen to be the king of kings, he was often represented by a lion.

BLACK CATS

In the Middle Ages, black cats were thought to be familiars—companions—of witches, and they were often seen as demons in disguise and creatures under the power of Satan. The black cat as a tattoo design may symbolize a belief in feminism, independence from male domination, or an admiration for pagan or Wiccan spiritual beliefs. A variation of this design is the black panther, symbol of X-rated or restricted movies, so there is a strong element of the sensual and erotic in the black cat or black panther tattoo.

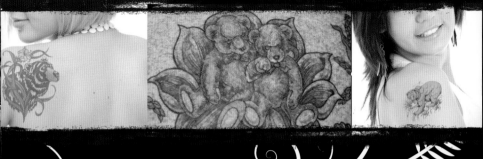

BEARS

The bear is a powerful animal totem or spirit in shamanistic and animist belief systems, acting as a protector and source of inspiration. Famous for hibernating, the bear was believed to gain wisdom through its winter-long incubation. Shamanic people in Europe and America took the bear as a symbol of awakening the power of the unconscious. Strong, swift, quiet, and extremely protective of family, the bear has become a symbol of maternal protection. Other qualities that the bear projects include strength in the face of adversity, bravery, solitude, and attention to the practical side of life.

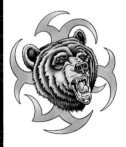
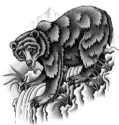
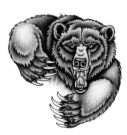

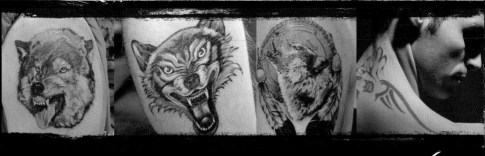

WOLVES

Modern dogs are descendants of Asian wolves, and the domestication of the wolf is a microcosm of the complex relationship between man and nature, representing the ongoing struggle for survival against indomitable elements. The wolf often represents the spirit that must be tamed, domesticated, and civilized. Wolves as predatory competitors with early man symbolized ferocity, cunning, stealth, cruelty, and even evil, but because of their close-knit pack behavior also represented loyalty, courage, fidelity, and victory. The tendency of wolves to hunt at dusk and dawn and to communicate by howling at night caused their association with the spirit or shadow world, shape-shifters, and malevolent or evil spirits. They symbolized fear of the night, darkness, and even demonic possession. At the same time, men could not help but admire the skill and success of the wolf pack.

In early Christianity, the symbolization of Christ as the good shepherd, who protects his flock, the faithful, from predation, made the wolf a potent symbol of Satan.

The myth of the werewolf speaks to the fear that a wild animal, in all its savagery and primal impulses, lurks deep in the breast and hearts of all men, needing but one fateful bite and a full moon to be unchained and released.

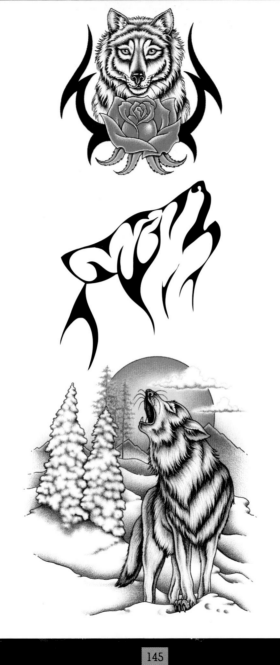

ELEPHANTS

Elephants in Africa and Asia were associated with kings, emperors, and nobility, and were used in warfare. In India, the god Ganesh has the head of an elephant. In Asia, elephants are revered as symbols of benign divinity; during religious ceremonies, people make offerings to elephants, wash them, and anoint them with special oils, seeking their blessings.

In times of drought, elephant herds remember which watering holes are the most reliable, spawning the myth that an elephant never forgets. Elephants also come to the aid of another elephant in trouble, and often refuse to leave the body of a dead elephant for several days. Because of these traits, elephants are symbols of wisdom, loyalty, strength, and longevity.

BULLS

The bull's male fertility, fiery temperament, and role as father of the herd make him the masculine sun god in many cults. But his crescent-shaped horns also link him to feminine moon symbolism. The bull's association with the sun makes it a symbol of the heavens, resurrection, and fire; while its association with the moon makes it a symbol of water, night, and death.

The bull tattoo is a symbol of power, strength, resurrection, masculinity, fertility, impulsiveness, fathers, kingship, and the zodiac sign and constellation of Taurus. Bulls are also emblems of tyranny, ferocity, stubbornness, lust, brutality, and the devil.

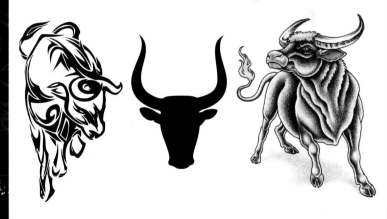

THE CHINESE ZODIAC

Each year of the 12-year cycle of the Chinese zodiac is related to a particular animal. The animals are symbolic of various personalities and characteristics that influence the lives of the people born under that sign.

RAT

Born in the years 1912, 1924, 1936, 1948, 1960, 1972, 1984, 1996, and 2008. The rat was welcomed in ancient times as a protector and bringer of material prosperity. It is an animal associated with tenacity, fighting spirit, self-preservation, aggression, charm, and charisma; yet also associated with death, the occult, torture, crimes, poverty, and disease. Those born in a rat year are usually good with money and have a fine entrepreneurial spirit.

OX

Born in the years 1913, 1925, 1937, 1949, 1961, 1973, 1985, 1997, and 2009. The ox is a sign of prosperity through fortitude and hard work. This powerful sign is a born leader, possessing an innate ability to achieve great things. Such people are dependable, calm, and modest. Like their animal namesake, the ox personality is unswervingly patient, tireless in their work, and capable of enduring any hardship without complaint.

TiGER

Born in the years 1914, 1926, 1938, 1950, 1962, 1974, 1986, 1998, and 2010. The tiger, associated with good fortune, power, and royalty, is viewed with both fear and respect. Their protection and wisdom is sought after, and many people in China and the East see the tiger, and not the lion, as the king of beasts.

RABBiT

Born in the years 1915, 1927, 1939, 1951, 1963, 1975, 1987, 1999, and 2011. It is thought that those born in the year of the rabbit are virtuous and have excellent taste. The rabbit personality is said to be quiet, reserved, retrospective, thoughtful, and lucky, and rabbit people are admired, trusted, and often financially lucky.

DRAGON

龍

Born in the years 1916, 1928, 1940, 1952, 1964, 1976, 1988, 2000, and 2012. The dragon is the only mythical animal in the Chinese zodiac. In China, dragons are associated with strength, health, harmony, and good luck: They are placed above doors or on the tops of roofs to banish demons and evil spirits. Within Chinese cultures, more babies are born in dragon years than in any other animal years.

SNAKE

Born in the years 1917, 1929, 1941, 1953, 1965, 1977, 1989, 2001, and 2013. The person born in the year of the snake is perhaps the wisest and most enigmatic of all. He/she can become a philosopher, a theologian, a political lizard, or a wily financier. Such a person is a thinker who also likes to live well. The snake personality loves books, music, clothes, and fine food; but with all their fondness for the good things in life, their innate elegance gives them a dislike for frivolities and foolish talk. Those born under the sign of the snake are said to be rich in wisdom and charm, intuitive and romantic, but also prone to sloth and vanity.

蛇

HORSE

Born in the years 1918, 1930, 1942, 1954, 1966, 1978, 1990, 2002, and 2014. The horse personality is often willing to give as well as expecting a lot of liberty. These people are extremely independent and confident. A person born under the horse is quick witted, inquisitive, and determined. In general they are gifted, but in truth they are often more cunning than intelligent—and they surely know that. They adore being the center of everyone's attention, but prefer to be recognized for their skills and are easily flattered.

SHEEP

Born in the years 1919, 1931, 1943, 1955, 1967, 1979, 1991, 2003, and 2015. Also known as ram or goat, the sheep, oddly enough, is thought to be the most artistic and creative sign of the zodiac. The sheep is artistically talented and has a great sense of fashion. Chances are that this type will prefer to be a designer or painter, or go into the kind of profession where they can make the most of their gift for creating beautiful things.

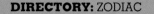

MONKEY

Born in the years 1920, 1932, 1944, 1956, 1968, 1980, 1992, 2004, and 2016. Monkey personalities are said to have agile minds and multiple talents that allow them to master any subject. They are also associated with adultery, justice, and with sorrow. The monkey is super-quick and multitalented, but has a tendency to be an opportunist. The overconfident monkey could end up losing face.

ROOSTER

Born in the years 1921, 1933, 1945, 1957, 1969, 1981, 1993, 2005, and 2017. In some regions of China the rooster is replaced with the phoenix. This personality is observant, honest, and loyal, and likes to be noticed. Roosters are happiest when they are surrounded by others, and tend to brag about their achievements if given the chance.

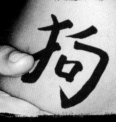

DOG

Born in the years 1922, 1934, 1946, 1958, 1970, 1982, 1994, 2006, and 2018. Dog types are honest, intelligent, and straightforward. They will take on any responsibility that is given to them, and you can be sure that they will do their job well.

PİG

Born in the years 1923, 1935, 1947, 1959, 1971, 1983, 1995, 2007, and 2019. In China, the pig—a more correct form would be the boar—is associated with fertility and virility. To bear children in the year of the pig is considered very fortunate, for they will be happy and honest. Pig types are modest, honest, patient, and love nature.

THE GREEK ZODIAC

The Greek zodiac signs are favorite tattoo designs. Originally borrowing the idea from the Babylonians, by the sixth century the ancient Greeks had their own version of the 12 heavenly signs, better known as the zodiac.

As the sun and the planets traverse the heavens, their influence is said to impact upon mortals on Earth, affecting the character and personality of those born under a particular sign. In time, a mythology evolved around each sign of the zodiac.

Aries

Taurus

Gemini

Cancer

Leo

Virgo

Libra

Scorpio

Sagittarius

Capricorn

Aquarius

Pisces

ARIES THE RAM
March 21 to April 20
Aries is a fire sign, and those born under it are fast to learn and fast to act, but impatience can hinder or sabotage their progress. The Aries character is naturally good-hearted and generous. The saying "a friend in need is a friend in deed" suits the Aries personality, who readily offers his gifts and his home to a friend.

TAURUS THE BULL
April 21 to May 20
Responsible at work and loyal in relationships, strong Taureans tend to take on others' burdens, but they can become possessive, jealous, and overprotective of loved ones. Patience and understanding make those born under this sign ready and willing friends. Taureans can provide others with emotional and material security.

GEMINI THE TWINS
May 21 to June 21
Others may swoon in panic, but Gemini remains calm and unruffled. With a highly evolved sense of order, it's not surprising that tempers fray when things don't go the Gemini way. Those standing too close may suffer as a result. Keeping busy is important for the talented Gemini. A satisfied Gemini is charming and witty.

CANCER THE CRAB
June 22 to July 22
Cancer is a curious, and complex water sign. Partnering up and making a home has great appeal for this sensitive soul. When anxious or worried, Cancerians have a tendency to brood; shy in public, they may unwittingly conceal their true character.

LEO THE LION
July 23 to August 22
Leos make excellent leaders, with a tendency to talk louder than anybody else around. The Leo can be inspirational when interested in a topic or project. Noble and proud, this fire sign can also be philosophical. Leos are lovers of nature—and the opposite sex—enjoying a romp in the open air or a swim in the ocean.

VIRGO THE DIVINE VIRGIN
August 23 to September 22
Those born under this sign have been called nit-picking perfectionists, even by their friends. They don't favor soppy bear-hugs, preferring to keep their distance until they have sniffed out faults and imperfections. When approval is won, the Virgo character makes a good and loyal friend, willing to help unstintingly.

LIBRA THE SCALES
September 23 to October 22
Justice is what this air sign is all about. Libras like to please others and relish approval from their loved ones. These social animals are interested in world events as well as what's going on in their own circle of friends, but when Librans get embroiled in an argument, they often go too far and wish they could eat their words.

SCORPIO THE SCORPION
October 23 to November 21
When it comes to a battle of wills, Scorpios are the favored contenders. Intuition is a Scorpio characteristic, as is a strong sense of justice. Scorpios are honest and make good friends. With their strongly emotional disposition, they can be possessive of people.

SAGITTARIUS THE CENTAUR
November 22 to December 21
Animals and all things natural warm the heart of this
fire sign, who loves freedom and space and exploring the
great outdoors. New ideas, events, and people delight
the friendly Sagittarian. Spontaneous and fun-loving,
with a sound ethical sense and concern for others, the
Sagittarian has strong leadership qualities.

CAPRICORN THE HORN OF PLENTY
December 22 to January 19
Disciplined, patient creatures who are up for the
challenge, the Capricorn has a sense of humor and a love
of things intellectual. They are known to be kindhearted,
loyal, and careful with money. A love of beauty and
strong management skills give the Capricorn a head start
in getting to the top.

AQUARIUS THE WATER CARRIER
January 20 to February 19
Those born under the sign of Aquarius like to be different,
have a quirky sense of humor, and can be relied upon to tell
a good story. Their cerebral tendencies may cause a chill in
other areas, but they love new ideas and concepts and don't
waste any time communicating these to the world at large.

PISCES THE FISH
February 20 to March 20
Naturally sensitive, the Piscean makes an empathetic lover
and friend. At times weak and indecisive, they can also
respond with a stubbornness, the likes of which neither
reason nor logic can dislodge. When in love, the Pisces sees
no fault in the beloved and is willing to sacrifice themself.

STARS

As lights shining in the darkness, stars are often considered symbols of truth, the spirit, and hope. The symbol of the star embodies the concept of the divine spark within us, while the nocturnal nature of stars leads them to represent the struggle against the unknown.

Stars with a specific design take on an explicit meaning and symbolism. The five pointed star, or pentagram, incorporates the oriental yin and yang symbol to emphasize its harmonizing nature. This star's symbolism is dramatically altered by its orientation. A downward-facing pentagram was thought to be a sign of the devil. In Celtic lore the pentagram was the sign of storytellers and magicians; the five points a powerful symbol of protection and balance.

The hexagram is a potent symbol of the interaction of the divine with the mortal. It has particular significance in Judaism as the Star of David. The septagram is a symbol of integration and the mystical, due to its links with the number seven. It is associated with the seven planets of classical astrology and to other seven-fold systems, such as the Hindu chakras. The octagram star is a symbol of fullness and regeneration, and is linked to eight-fold systems such as trigrams and the pagan wheel of the year. The nonagram is a symbol of achievement and stability. It can also be related to nine-fold systems, such as the nine Taoist kanji (psychic centers). *See also* Star of David, page 184.

MOON DESIGNS

One of the Twelve Symbols of Sovereignty (imperial authority) of Chinese custom, the moon is a symbol of heaven, representative of the passive principle (yin) to the sun's active principle (yang). In Western astrology the moon is said to represent the feeling nature of the individual. It is used to characterize the inner child within us, as well as the past and how we have been as individuals, rather than how we are now.

The Assyrians held the moon to be the supreme deity, while moon worship existed in ancient Greece, Babylonia, India, and China; a belief based on the observation of how the moon's phases affected the growth and decline of crops and animal and human life. When moon worship clashed with established religious practices—particularly in Europe—many signs and symbols associated with the moon were considered evil or demonic. Bats, black cats, and witches on broomsticks, with the full moon lighting their way, became symbols of darkness and evil.

Astrologers point to the moon as the ruler of the emotions, characterized by fickle changes and fluctuations. Both East and West associate the moon with the mother, nurture, and the home. It is universally associated with water and tides and the female cycle of menstruation. The moon looks outward, shining its light on others, and has become synonymous with the traditional feminine principles of caring and giving comfort to others.

Receptivity and melancholy are also seen as moon aspects, but they are in no way associated with any dwindling of power. The moon is also closely associated with the many animals that come out at night, such as wolves, coyotes, panthers, jaguars, leopards, owls, and bats. In some Native American cultures it is thought that wolves and coyotes are howling at the moon when they make their familiar cries.

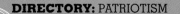

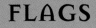

FLAGS

Flag tattoos symbolize the love, devotion, and patriotism that the wearer has for their country. They can be straightforward renditions or heavily stylized, and are often designed to show the colors of the national flag within an outline of the shape of the country in question. Emigrés or immigrants often get tattoos that pair the flag of their old country with that of their new one.

Flags often play a prominent role in the tattoos worn by people serving in the military services. This is especially true among servicemen and women in the United States and Great Britain.

In memorial tattoos dedicated to fallen comrades, a fallen or draped flag, or a flag at half-mast, is a powerful symbol of the ultimate sacrifice, a life given in the service of protecting one's country.

For gay and lesbian people, tattoos showing the rainbow flag are very popular, while other groups that have symbols with which they strongly identify will often fly that symbol as a flag—even anarchists. As tattoo symbols, flags are rarely represented with straight lines, and many tattoo artists use great creativity when draping the colors of a flag around arms, over shoulders and chests, and across backs.

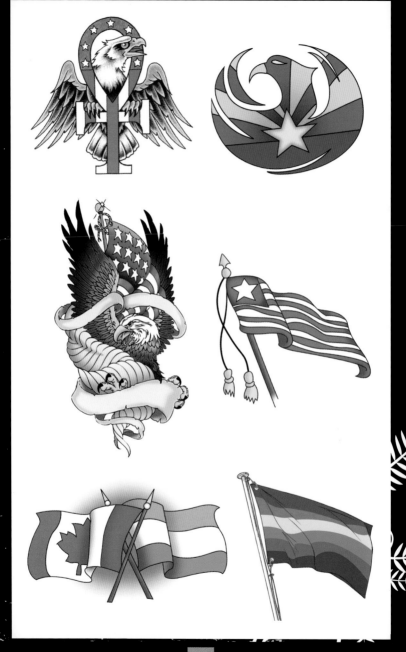

BARCODES

The barcode system of price checking and inventory control was designed in the 1950s, as a way to increase efficiency and worker productivity.

The use of the barcode as a tattoo design is ironic, a warning that we are in danger of becoming products ourselves. A barcode tattoo is also a protest against a society in which everyone wears the same clothes and listens to the same music. A barcode tattoo is a statement against a commodity culture and a celebration of diversity and the uniqueness of the individual.

Punk music enthusiasts in particular have embraced the barcode tattoo, along with the symbol for anarchy.

ANARCHY

The usual symbol for anarchy is a stylized letter "A" within a circle. Political anarchists prize the rights of the individual and minorities over those of the majority, and when it first came into use over 150 years ago, the anarchy symbol was used to protest against oppressive governmental regimes, monarchies, and states that outlawed unions. As a tattoo symbol, the anarchy "A" is popular with groups whose members consider themselves to be on the fringes of accepted society. It has, at various times, been embraced by punks, skinheads, and the gay community. It has also been used to protest against globalism in the form of global-capitalism or industrialization. Other symbols of anarchy include the color black, a symbol of a raised clenched fist, and variations on the skull and crossed bones, the chosen flag of pirates who sail for no nation but themselves.

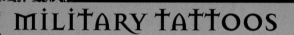

Military Tattoos

Like tattoos with explicit spiritual and religious symbolism, military tattoos often have a strong element of the amulet or talisman connected to them. A tattooing ritual carried out by a shaman, medicine man, or priest, accompanied by incantations and using pigment believed to have special or magical properties, might render an individual invisible or impervious to the weapons of opponents (a belief still held in places like Burma and Thailand). The tattoo acted in the mind of the recipient as a primary line of defense; a potent psychological barrier; and, taken literally, an actual piece of armor.

In cultures where an individual's life history was represented in their body art, tattoos could display their prowess in battle. The Maori marked their personal military histories with tattoos and, for an Iban headhunter, every head taken was marked with special tattoos on the hands. For other soldiers, specific tattoos that represented a religious affiliation would ensure that if they fell in battle, they would receive a proper burial.

In Hawaii and the Marquesas Islands, Captain Cook encountered an indigenous tattoo worn only by the warrior class, and which served a truly military purpose: tattoo as camouflage. The warrior's body was fully tattooed, but on one side only. This half-body tattoo would be presented to the enemy in combat. Presumably, this left him with a clean side to present in civilian, domestic, and perhaps even romantic affairs.

By the beginning of the nineteenth century, as more and more sailors returned from distant lands, tattooing had become highly popular in the British Navy, and spread even to the British Admiralty.

When a person receives a tattoo to signify membership of a group, the shared pain acts as the all-important shared experience. Getting a tattoo proved that the young recruit had the ability to withstand pain with stoicism and gave him a profound sense of belonging to an enterprise larger than himself.

COATS OF ARMS

A tattoo of a family coat of arms serves to celebrate family ties and heritage. In Great Britain, whether you are English, Scottish, Irish, or Welsh, and in most of the countries of Europe, individuals can often trace their family history to a particular stylized design that at one time would have decorated shields and banners as a method of identifying individuals going into battle.

The term coat of arms derived from the practice of medieval knights or nobleman, who wore an embroidered garment over their metal armor; a coat bearing the crests or symbols of their rank and personage. Prior to this innovation, one armored knight looked much like the next, so by his coat of arms he could be identified to his followers in the heat of battle. It is believed that the first example of a coat of arms applied to a shield was that of Henry I of England, in AD 1127, at which time many northern European nobles, Saxons in Germany, and Vikings in Denmark, Norway, and Sweden were tattooed with marks that identified them as belonging to particular families and alliances.

With the increasing popularity of the tournament, the coat of arms became the mark of noble status, and no knight could participate without bearing a coat of arms. For many years the individual knight or nobleman could take a coat of arms for himself, but later it could only be granted by the monarch. Subsequently, it could be passed down through heredity. The family name alone, however, did not bestow the right for those bearing that

name to own the coat of arms. The emblems were guarded as heirlooms and were the private property of specific individuals.

The earliest coats of arms were simple designs, but with time they became increasingly more complex and ornate. They included crests, supporters, and mottoes; even incorporating the arms of other families through marriage. The term "heraldry" referred to the description and placement of the symbols on the shield. When the heraldic artist came to depict the symbols, exact and precise knowledge of each one was critical. They were recorded in a special register, and no symbol could be duplicated, according to royal law.

With the gradual disappearance of the tournaments and the eventual dwindling of private armies, the military and sporting use of the coat of arms fell away, giving way to heraldry based on family pride. Representatives of noble families often wore part of the design of the coat of arms on their uniforms to show in whose employ they were retained and as a mark of prestige. Military units that were led or funded by a noblemen often incorporated part of a family or individual's coat of arms into the markings of the regimental coats of arms.

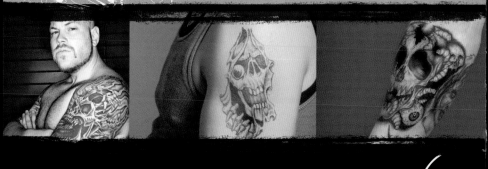

DEATH

Many tattoo designs that feature death in some way also represent life, rebirth, and the ideas of resurrection and reincarnation. The phoenix is a classic example of this; despite a fiery death, it rises again out of its own ashes, reborn at the beginning of a new cycle of life. A tattoo design symbolic of death is not necessarily a morbid one, but one that reminds us to treasure every breath of life. In fact, given human nature and our tendencies toward superstition, such tattoos are often seen as powerful amulets and talismans against death. And when death does come, there are many cultures that believe that being heavily tattooed is the best way for an individual to ensure a safe passage to the other side. *See also* phoenix, pages 128–9.

SKULLS

In many cultures, the skull is held up as a reminder of death and of human mortality. Historically, the skull was a symbol of triumph, and a warning to those defeated in battle. The skull was the Nazi SS insignia—a symbol to be feared—but when tattooed on the arm of a biker outlaw, it is believed to cheat death. In Victorian times the skull, in combination with crosses, roses, and wings, was a reminder of mortality as well as resurrection and eternity. An ancient symbol of the skull with a serpent crawling through it was a symbol for knowledge and immortality, and is a popular tattoo design to this day.

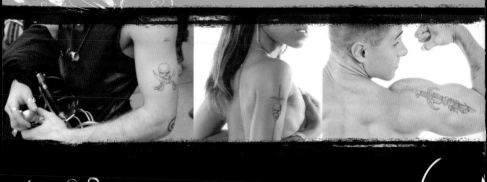

SWORDS

The sword symbolizes liberty and military strength. As a warrior's symbol, the sword is emblematic of honor, and should incite the bearer to a just pursuit of virtue. Thus a sword was a prominent feature in heraldic crests.

During the Middle Ages the sword was a symbol of the word of God, and when borne with a cross, it signifies the defense of the Christian faith. The sword, especially alongside flames, also symbolizes purification.

The usual form for the sword is a long, straight blade with a cross handle, though the blade may also be stained with blood. A sword is often depicted piercing an animal or a human heart, and two swords crossed in saltire is an emblem of Saint Paul. *See also* coats of arms, pages 170–1.

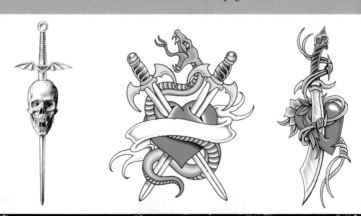

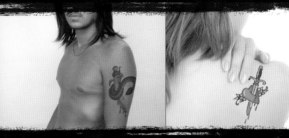

DAGGERS AND KNIVES

The ability to spill blood, the very essence of life, is a potent symbol. At its most primal level, the knife or dagger represents death. Daggers and knives are silent weapons, perfect for close fighting, and as such figure in many military tattoos. The knife or dagger indicates ferocity, quickness, tenacity, and death at the hands of another, and can also represent an assassin.

When the rich and wealthy began to decorate the hilts of their daggers with gold and jewels, they became potent symbols of rank.

Expressions such as, "stabbed in the back," or "stabbed in the heart," have inspired many tattoo designs.

MEMORIAL TATTOOS

When we want to remember a special person, place, or moment in time, pay tribute to a lost loved one, mark a journey, or ensure that we never forget a particular day, tattoos make striking visual reminders of the memories that we seek to permanently preserve. The memorial tattoo can be an exact representation of the object to be remembered, such as a portrait or a symbolic mark, for example a name, date, zodiac sign, or kanji icon. Other popular motifs include roses, stars, birthstones, and favored objects of the deceased, such as an animal or instrument. Angels are often chosen to mark the death of a child. It is wise to give your grief a cooling-off period in order to choose the best design to help you remember in the long term. Take time to find the right image; one that celebrates life rather than mourns loss. *See also* angels, pages 190–1 and cherubs, page 87.

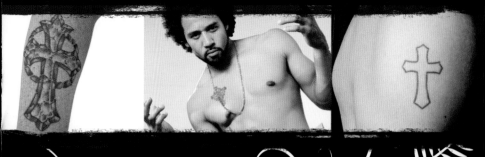

THE CROSS

There is perhaps no religious icon more universally recognized than the cross. However, even long before it was adopted as a Christian symbol, the cross was a widespread sacred icon. It symbolized immortality, fertility, and the union of heaven and earth. Its four arms symbolized the points of the compass, the four winds, the elements, and the human form itself.

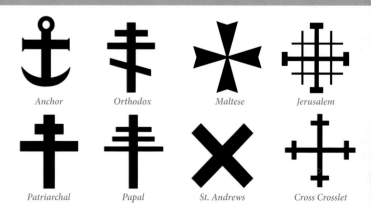

Anchor *Orthodox* *Maltese* *Jerusalem*

Patriarchal *Papal* *St. Andrews* *Cross Crosslet*

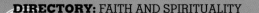

FAITH AND SPIRITUALITY

There has always been a spiritual element to the practice of body art and body modification. Even before the rise of organized religions, with their widely recognized symbols of faith and devotion, tattoos were intended to serve a purpose beyond simple expressions of decoration and identification. Many early tribal tattoos clearly had a cosmic connection and wove early man into the fabric of the larger universe. Early cultures often inscribed themselves with animal images and totems; probably in an effort to evoke the power of the animal spirits, possibly for success in the hunt, but also for protection. Even today, in one of the remotest parts of the planet, the Kayan tribesman in Borneo receives hand-tapped tattoos on both shoulders to guarantee his safe passage, as a departed soul, across the River of the Dead (see page 38).

Nowadays, in a tattoo culture where much of the artistry is for decorative purposes only, the resurgence of religious tattoos is again bringing the faithful into the tattoo studio. You can credit evangelical Christians for helping to make religious motifs one of the most popular sectors of the current tattoo industry. Approximately 20 percent of the tattoos inked in North America today are religious in nature, and undoubtedly the wearer sees their body art as a way of proclaiming their faith to the world.

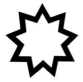

Bahai

Buddhist

Buddhist

Christian

Christian

Confucian

*Confucian/
Taoist*

Hindu

Judaic

Judaic

Judaic

Islamic

Sikh

Shinto

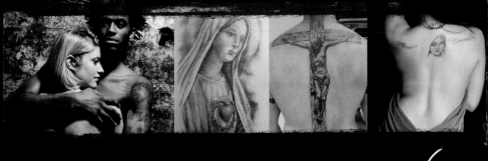

CHRISTIANITY

The most popular Christian symbols are crosses, angels, doves, and praying hands, and the Christians who choose to wear these tattoos do so because they wish to permanently express their individuality, identity, and faith. Symbols of Roman Catholicism are also extremely popular, and within Latin culture you will see rosary beads, the Madonna, the crucifixion, the crown of thorns, and sacred hearts prominently featured, along with the more standard crosses and angels. Pilgrims who made a successful pilgrimage to Jerusalem also marked the occasion with a tattoo, such as the date of their pilgrimage, Saint George on a horse killing a dragon, Christ on the cross, or the Virgin Mary holding the infant Jesus.

İSLAM

The Koran may be seen to forbid tattooing, depending on your translation of "The guilty are recognized by their marks." However, the practice of marking the skin was not uncommon among Muslims who journeyed to Mecca or Medina. If tattoos were going to be a problem for a Muslim, it was usually upon admission to paradise. This ceased to be a concern if the wearer was sure he would be purified by fire before entry. For Muslims the first choice is usually the crescent moon with star, although this is a political rather than religious symbol. Verses from the Koran are hugely popular, usually in Arabic calligraphy. Overlapping verses with Christian symbols such as angels, Satan, and even Adam and Eve, is also meaningful.

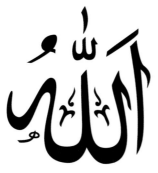

jVDAİSM

The hexagram is a strong symbol of Jewish identity that represents the interaction of the divine with the mortal. It gets its name from the thought that David carried a hexagram-shaped shield, or that a hexagram appeared on his shield, during his defeat of the giant Goliath. It has strong links with the Kabbalah, and is sometimes known as the Seal of Solomon or the Creator's Star. The six points each represent a day of the week and the center corresponds to the Sabbath.

During the days of Nazi persecution, Jews were forced to wear a yellow hexagram as identification. The star was incorporated into the flag of the State of Israel in 1948.

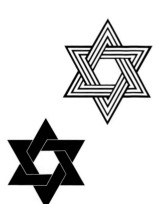

COPTIC

To the early Coptic Christians in Egypt, tattoos were part of their religious life. Pilgrimages were hugely important, and the only way to prove you had been to the Holy Land, for instance, was to return with a tattoo of the kind that only a Coptic priest was permitted to apply. The designs were applied from woodblocks in order to speed up the process, the most common tattoo being a small cross on the inside of the wrist. Operating from a stall outside the walls of Jerusalem, the priests' work was rough, but you might say it was the thought that counted. Only with the tattoo would folks back home believe you had actually prayed at the holy shrines.

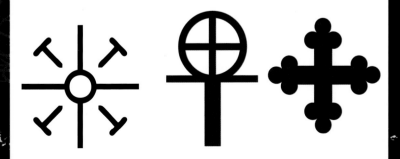

ROSARiES & PRAYiNG HANDS

The rosary—from the Latin *rosarium*, meaning crown of roses—is an important and traditional devotion of the Roman Catholic church, combining prayer and meditation in sequences of 10 Hail Marys, with each sequence known as a "decade." Various Buddhist groups use prayer beads that are similar to the rosary; thus they have been called Buddhist rosaries.

If the fifteenth-century German artist Albrecht Dürer were alive today, he would be a rich man. His brush drawing Hands in Prayer was originally commissioned as an altarpiece by the mayor of Frankfurt in 1508. A later version of these praying hands appeared in another Dürer work, only this time as the hands of an apostle standing at an empty grave looking heavenward at the coronation of the Virgin Mary. The original was destroyed by fire in 1729, but a copy of the altarpiece, as well as some earlier sketches, survived.

Today, Dürer's Praying Hands is not only the most widely known and frequently produced of his works, but it's one of the most popular tattoo designs of all times. The image continues to move people's hearts and minds, especially when combined with a variety of favorite tattoo icons, such as the cross or the rosary. It is often teamed up with hearts and halos, or the name of a loved one, as a memorial. Other hands appear with prayer text or holy scripts, or with wounds of the crucifixion and the holy fire.

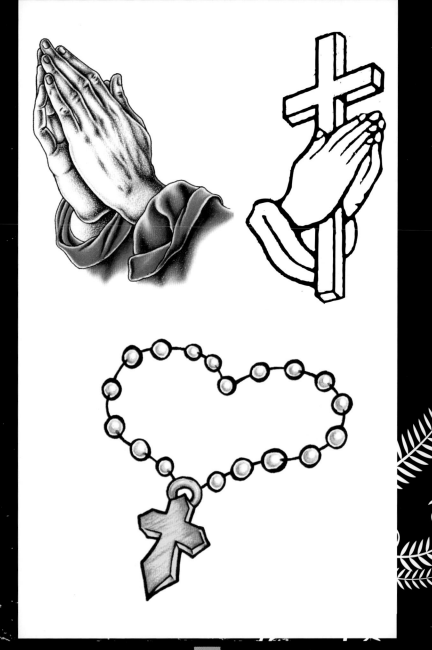

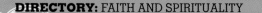

DEVILS & DEMONS

The devil is a supernatural entity, who, in most Western religions, is the central embodiment of evil. This entity is commonly referred to by a variety of names, including Satan, Asmodai, Beelzebub, Lucifer, and Mephistopheles. In classic demonology, however, each of these alternate names refers to a specific supernatural entity, and there is significant disagreement as to whether any of these specific entities is actually evil. The term devil can also refer to a greater demon in the hierarchy of hell.

In the tradition of the Christian church, Lucifer was an archangel, who had God's favor as the first angel among equals, but because of his vanity, hubris, and weakness of character he fell so far from God's grace that he was literally cast out of heaven when he led other angels in revolt.

Lucifer is a symbol for chaos, and a wild, uncontrollable spirit cursed with all the vices and worst aspects of the human condition. Images of Satan as being red, having horns, cloven hooves, and a tail are all efforts by a Church hierarchy to literally and figuratively demonize the image of the fallen Lucifer.

As a tattoo design, a devil symbolizes a mischievous, lascivious, and perhaps slightly wicked nature, with a predisposition toward all manner of sinful behavior and vices.

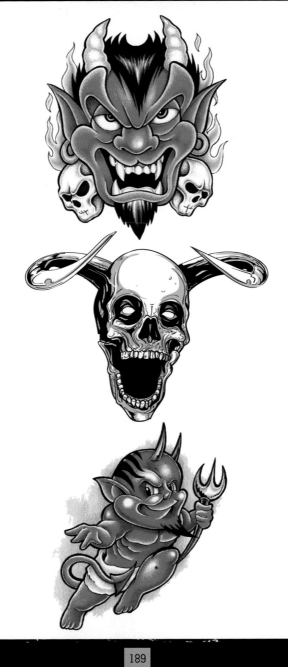

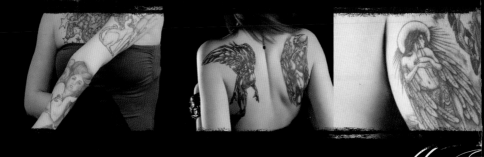

ANGELS

In a number of religions, angels are winged messengers of God. Symbols associated with angels include trumpets, harps, and swords. Angels are usually portrayed as young men with wings and halos, representing their divinity. As a tattoo design, an angel is a symbol of devotion, spirituality, and faith. An angel can be a figure of guidance and protection. An angel tattoo design is an overtly religious symbol. Angels are anthropomorphic—in the shape of men—winged forms intended to transmit the word of God to humankind. They personify divine will and are the messengers of God, in fact the word angel comes from the Greek *aggelos*, meaning messenger. Winged messengers feature in a number of religions as intermediaries between the spiritual and material worlds, but appear most often in Islamic, Jewish, and particularly Christian faiths. Angels make frequent appearances in the Bible, not only as messengers of God but also delivering his protection or punishment.

Symbols closely associated with angels in art include trumpets, harps, swords, sceptres, and wands. Angels are usually portrayed as young men with wings and halos, representing their divinity.

As a tattoo design an angel is a symbol of devotion, spirituality, and faith, and signifies a relationship with God. An angel can be intended as a figure of guidance and protection, and is often used as the centerpiece of a tattoo intended as a memorial.

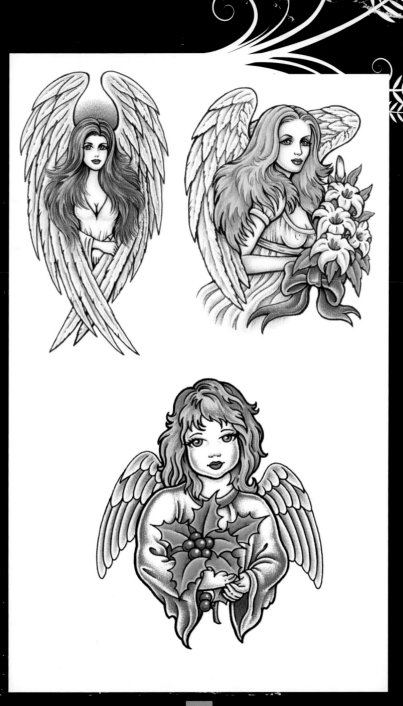

DOVES

Within some Christian denominations the dove is a symbol of the Holy Ghost, and is often used in representations of the baptism of Jesus Christ and the Pentecost. Most will be familiar with the Bible story of the great flood, which only Noah, his family, and the creatures aboard the ark survived. After many weeks at sea, Noah released first a raven, then a dove, to search for land. The dove returned with an olive branch, and Noah and his family rejoiced in the knowledge that the floodwaters were retreating. The dove became a powerful symbol as a harbinger of hope and peace. Others believe that the flight of a released dove also symbolizes the release of the soul in death.

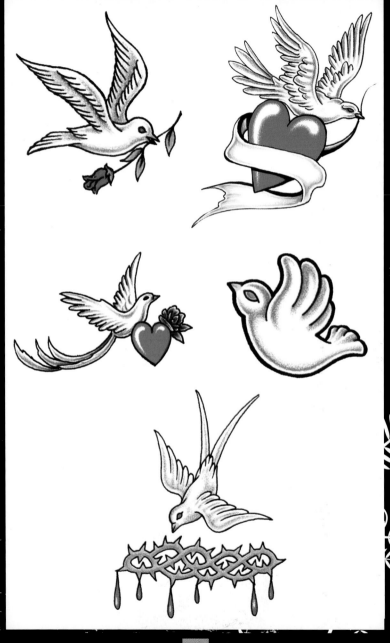

infinity

This tattoo design is best described as a figure of eight on its side, and is used to denote that which is limitless and without boundary or end. Circles and loops are reminiscent of the idea of life being conceived as an eternal, often seasonal cycle, that endlessly repeats itself. In many Eastern religions and belief systems the idea of endless reincarnation and planes of existence is similar.

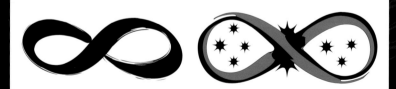

OUROBOROS

The serpent biting its own tail is a symbol that recurs through all eras and crossing many cultures. Symbolically it has several meanings. As a creature that is literally eating itself, it symbolizes the cyclical nature of the universe: creation out of destruction, life out of death. Alternatively it may be seen to be eating its own tail to sustain its life, in which case it symbolizes an eternal cycle of renewal. This secondary symbolism is an echo of the concept of infinity, of cycles without end, and an infinite universe without boundaries or limits.

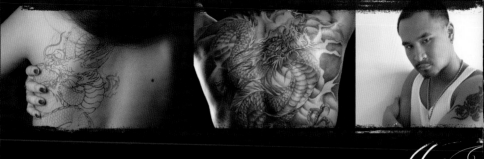

DRAGONS

Dragon tattoos are heavily influenced by Japanese and Chinese culture, where the dragon represents the four elements and the four points of the compass. In China, these mythological creatures were once the symbol of supernatural and imperial power. They became so embedded in Chinese legends that the dragon is said to be the ancestor of the Chinese people. In Japan, a similar claim was made when one emperor declared that he was a descendant of the immortal dragon. The image of the dragon appeared on the emperor's robes, signifying its protective powers as well as the emperor's temporal power. The rain-bearing power of thunder was often depicted as a pearl held in the dragon's mouth or throat. Over time, the dragon's pearl came to stand for the king's purity of thought and the perfection of his commands. "You do not argue with the dragon's pearl," said Chairman Mao.

Japanese folklore is filled with stories of creatures, in particular koi, that, through special quests and perseverance, are transformed into dragons. In Buddhist countries, the dragon is found over temple doors and on tomb walls, warding off evil. In the West, the dragon's serpentine looks connoted evil and, in its battles with Christian saints, the saint was always the winner.

Today, a dragon tattoo symbolizes nobility, magic, the power of transformation and imagination, perseverance, loyalty, power, and the ability to transcend the ordinary. *See also* koi, page 110; Chinese zodiac: dragon, page 150.

FAIRIES

The fairy as a tattoo design harks back to a rich folklore tradition in which fairies are used to explain the workings of destiny, with its unpredictable gifts and disappointments. The idea of supernatural beings who meddle in human affairs has created a genre of storytelling that is rich in symbolism.

The presence of magic makes fairies a favorite of children, and as a tattoo design they are a potent symbol of youthful innocence and a desire to retain a childlike imagination, wonder, and awe. They may also be used to denote the often overpowering presence of corporations in modern pop culture—think Tinkerbell.

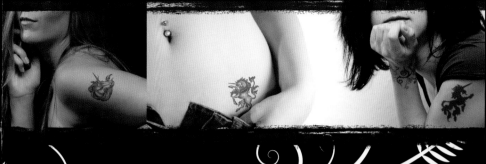

UNICORNS

The unicorn symbolizes beauty, mystery, nobility, strength, and a fierce temperament tamable only by purity and chastity. It is also an emblem of marital fidelity, because according to medieval lore, only a sweet, chaste virgin could tame the unicorn. The unicorn was a popular tattoo motif in the late 1960s and the 1970s, partly because it symbolizes a utopian world of peace and mysticism. It is sometimes depicted with a lion's tail and a goat's cloven hoof, symbolizing the ability to break free from bondage.

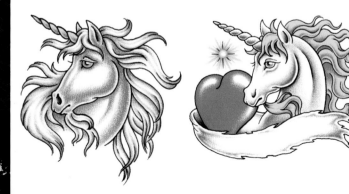

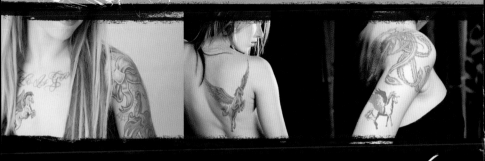

PEGASUS

Horse tattoos in general are popular, but the winged horse Pegasus is a particular favorite. The birth of this mythical steed came when the Greek hero Perseus slew Medusa with his magical sword, and from the blood gushing from her neck emerged the wild and magnificent Pegasus—who became the deliverer of Zeus' thunderbolts, and could be seen roaring across the skies. As a tattoo, Pegasus represents similar traits to a horse: loyalty, stamina, endurance, and speed; but with the added characteristics associated with wings and birds—freedom and a soaring spirit. Pegasus is thought to carry us to new heights of imagination and inspiration.

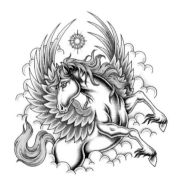

HORSESHOES

The horseshoe is perhaps one of the world's most widely known symbols of good luck. As a tattoo design it may stand alone, or be incorporated with other icons associated with good fortune, such as dice, playing cards displayed in winning combinations, and four-leaf clovers.

In many parts of Europe and North America, horseshoes are nailed over the doors of barns and houses, and depending upon the cultural and traditional beliefs of the area, may be installed pointing either up or down. Nailed with the ends pointing up, the horseshoe is intended to act as a cup to catch good luck; nailed down and all bad luck is poured out.

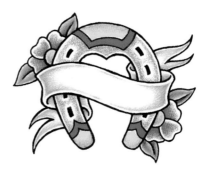

ΠAUTICAL

Nautical or maritime tattoos are derived from the very roots of modern tattooing. Sailors were among the first to revive the art and practice of tattooing when they visited the islands of Polynesia in the South Pacific and other lands in Southeast Asia. Captain Cook, in his famous explorations to Tahiti, Hawaii, and New Zealand, was the first to record the tattooing of the indigenous people in 1786. The word "tattoo" in the English language came from the Tahitian word *ta-taw*, which was thought to mimic the sound made by the traditional Polynesian tattooing implements. When the sailors returned to Europe with tattoos that were essentially exotic souvenirs of their travels and adventures, European audiences were fascinated.

Life at sea was hard and only the toughest men survived. Sailors, being at the mercy of the elements, and the capriciousness of Mother Nature, were a very superstitious lot. It did not take long for them to build up an extraordinarily elaborate set of tattoo symbols that spoke a language all their own. Tattoos told the story of where a sailor had traveled, and many were amulets and talismans of protection.

The expression "stewed, screwed, and tattooed" was born of the maritime tradition and served as a colorful synopsis of shore leave for sailors who had spent many months at sea. A good port of call often earned its reputation from the qualities, or lack thereof, of its drinking establishments, women, and tattoo artists.

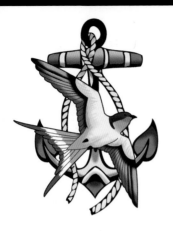

SWALLOWS
A sailor who had logged 5,000 miles at sea earned the right to a swallow tattoo. At 10,000 miles a sailor could add a second swallow. Swallow tattoos were also thought to be good luck in finding land and in returning to home port, because for sailors at sea, the swallow was a sure sign that land was close.

KNOT

A rope knot was meant to denote a four-knot sailor, or one who had crossed the Equator, International Date Line, and Arctic and Antarctic Circles.

DRAGON

A dragon tattoo showed that a sailor had sailed into a port in China, while a golden dragon was for sailors who had crossed the International Date Line (see pages 196–9).

TURTLE

A tattoo of a sea turtle showed that a sailor had sailed across the Equator.

SHARK

Sharks often trailed after ships, especially whaling ships, looking for scraps, and a shark tattoo was meant to prevent a sailor from being eaten if he accidentally fell overboard.

SHIP IN SAIL

A tattoo of a full-rigged ship indicated that a sailor had made the passage around Cape Horn. Such a sailor was also entitled to a small blue star on his left ear. Five times round the Cape and he could add a star to the right ear. And if he were a salty enough old sea-dog to make the perilous passage 10 times, he was entitled to two red dots on the forehead.

SAILOR'S GRAVE

A rather macabre variation of the homeward bound tattoo (see page 12) was the sailor's grave. This tattoo often showed a sailing ship sinking beneath the waves, its bow thrust up on a reef or rocks, with a terrible hole ripped into the belly of the ship. Like tattoos of skulls or demons, these were often made as talismans of protection, and acted as a reminder of just what a harsh mistress the sea could be.

ANCHORS

The anchor has been a fixture of modern Western tattooing for the better part of two centuries, and has ancient symbolic roots going back several millennia. It is a favorite of individuals who are associated with maritime or naval careers, and is closely identified with sailors all over the world. Many young sailors got an anchor tattoo to commemorate their first crossing of the Atlantic.

In ancient times the anchor, like the fish, was a symbol with ties to the early Christian church. An anchor tattoo can be thought of as holding one steadfast, like an anchor holding a great sailing ship safe in harbor, against the winds and currents that might carry it astray.

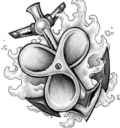
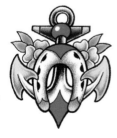

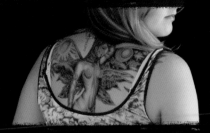
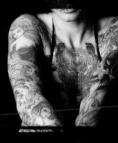

GIRLS

Girls in tattoo designs may serve to remind the wearer of a loved one, or warn him to avoid a certain type of woman.

PINUP GIRLS

Pinup images could be photographs cut from magazines or newspapers and stuck on walls, or appear on calendars and mass-produced posters.

One pinup girl, Bettie Page, was so popular that she was named Miss Pinup Girl of the World. She remains the "queen of pinup," and an inspiration to tattoo aficionados everywhere, which means that many tattoos of pinup girls bear a strong resemblance to Bettie Page.

MERMAIDS

A mermaid is a legendary creature; half human and half fish. Mermaids are symbols of female energy with the underlying threat that a sailor would be lured to his death by drowning if he pursued one. Sirens are similar—beautiful, womanlike creatures who would lure ships to wreck upon the rocks. According to Greek myth, mermaids were the result of unions between gods and sea creatures and were identified with the goddess Aphrodite, who was born from the sea and symbolized erotic love and fertility.

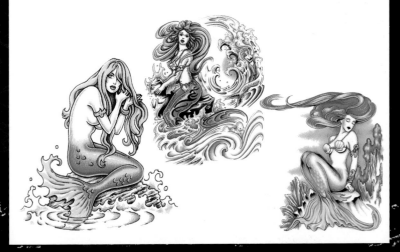

PIRATES

From the Latin *pirata*, meaning marine adventurer, other names for pirates include buccaneer, freebooter, and skimmer. A pirate is one who robs or plunders at sea without a commission from a recognized sovereign nation. Pirates usually target other ships, but have also attacked targets on shore.

Originally many pirates and buccaneers were working at the behest of governments or Royal decrees: When countries were at war or feuding, they often contracted independent captains as privateers to attack and harry enemy shipping while their own naval fleets were engaged. The Spanish considered Sir Francis Drake a pirate and there was a price on his head if captured, but he was authorized by a letter from Queen Elizabeth I of England to act as a privateer, and she expected to get her fair share of the spoils of war.

Ultimately, many privateers became pirates and did not distinguish between the countries of origin of the ships they attacked. Acting independently, these pirates indiscriminately attacked and plundered every ship they came across. Such behavior could quickly earn a pirate a price on his head, but some were so successful, and so difficult to catch, that they were offered pardons if they ceased their ways.

Unlike the stereotypical pirate with cutlass and masted sailing ship, today most pirates get about in speedboats wearing balaclavas instead of bandanas, and using AK-47s rather than cutlasses. Pirate motifs are still strong favorites with tattoo enthusiasts around the world.

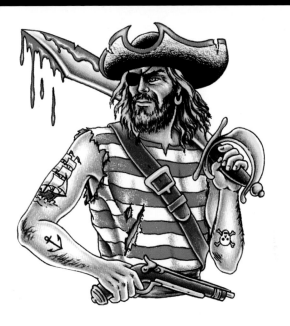

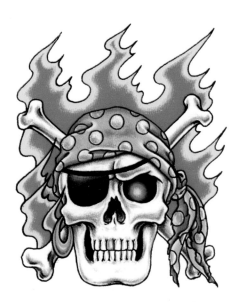

JOLLY ROGER

The skull over crossed bones or cutlasses symbolizes a life of swashbuckling on the high seas. Originally, French pirates flew their "pretty red" (*jolie rouge*) flag when they intended to take no prisoners. Its message was simple: give up or die; a declaration of ferocity meant to induce a quick surrender. During World Wars I and II the Jolly Roger appeared on British submarines to announce success in combat, and it is now the emblem of the Royal Navy Submarine Service. In the USA, the skull and crossbones is associated with aviation and appeared on fighter squadrons in World War II. But if you see it on a bottle, discretion is advised, because it indicates poison.

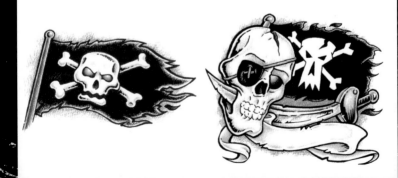

MAN'S RUIN

"Man's Ruin" is a tattoo design usually depicting an attractive woman of uncertain virtue, surrounded by many of the vices that can lead a man astray in life. Not the least of these is the woman herself. This woman is often surrounded by drinking glasses (a martini glass is a favorite), bottles of alcohol, playing cards, dice, and other accoutrements of gambling such as horseshoes, to represent betting on the ponies at the track. Use your imagination to add other elements of various modern vices. This woman is regarded as cruel or malicious, and is occasionally referred to as a "she-devil," in which case she may be featured with a devil's horns and tail.

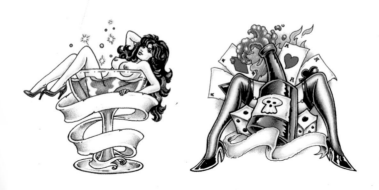

SCRIPTS

A picture may speak a thousand words, but there are times in life when a few well-chosen words can say volumes and move mountains. A heart tattoo is one thing; a heart tattoo that says "Mom" or "Dad" in a ribbon or scroll across it takes it to a whole new level. Getting a tattoo with the name or the initials of the one you love can be a greater commitment than getting married. You may part ways with the one you once loved, but the tattoo will remain.

Political prisoners often tattooed slogans on their bodies as their only form of protest, and prisoners and gang members still tattoo powerful words on themselves as a form of identification and affiliation. Foreign languages are popular, with Japanese Kanji and Chinese characters the best known, but people may choose passages important to them in Greek, Spanish, Latin, French, Sanskrit, Farsi, and many other languages. Another way to make a passage or saying unique is in the creative and imaginative use of fonts. Fonts are the styles of type used in printsetting. Some people may choose to have their family name tattooed in a Gothic script, while others decide on a more modern font that best suits their phrase. The names of loved ones have long been tattooed as if they were handwritten in a delicate script.

Biblical passages, proverbs, and hymns are popular in tattoo form, likewise Buddhist texts, which serve as reminders of spiritual truths and protect against evil. In India, some sects have sacred Hindu texts inscribed on every part of their bodies to protect them from harm—even inside the mouth. Mantras such as the sacred "om" are powerful, so should be correctly drawn and appropriately located, always high on the body (see page 183). Proportion and construction of the characters is also important, since the text sometimes gains power from its form, not just from its intellectual meaning. It is also a good idea to check out the implications of the sacred text you're considering. It's not cool, for instance, to take Koranic scriptures into the bathroom, or any place containing impurities.

Numbers can make for fascinating designs, especially since people consider certain numbers to be either lucky or unlucky. The birthdays and anniversaries of loved ones might also make it into a tattoo design. Lovers of rituals and ceremony, going back thousands of years, believe in a direct

link between man and God through the properties of certain numbers. Kabbalists, Masons, and Hindus use the "sacred three," multiples of which create the "mysterious nine," in rituals performed to acquire divine attributes. The old favorite seven is still considered to be a perfect number in cultures springing from ancient Greece, while eight signifies good luck, power, and material wealth in cultures originating in China. The number 13 has an unlucky history. In medieval times, witches in Europe were believed to have supernatural powers associated with the cycles of the moon, of which there are 13 in one year. However, in many religions, 13 has positive associations, such as rebirth for some Christians, mercy for those of Jewish faith, and remembrance of God for Sikhs.

An increasingly popular motif is the ambigram, a graphic figure that can be flipped, mirrored, or inverted, yet whichever way it is viewed it spells out the same thing. It is sometimes referred to as an inversion or flipscript. For tattoo aficionados, there is a dictionary of ambigram designs to choose from, and a great range of scripts and fonts, from simply elegant to graphically Gothic. A design may consist of a single word or an entire phrase. Depending on the ambigram's concept, it can be rotated, reversed, or reflected in mirrors, with the meaning sometimes changing, sometimes remaining the same. Many people choose to have an ambigram tattooed on the forearm, where they can flip it one way or the other, giving viewers the full effect of the design.

Cattle brand tattoo designs are an interesting take on monogram tattoos. The origin of livestock branding goes back several thousand years. The ancient Egyptians, Greeks, and Romans marked livestock—and slaves—with hot irons. Prisoners and criminals were also branded with marks to identify their crimes.

Livestock brands, particularly when used for cattle and horses on the American Western frontier, evolved into a language all their own. To the uninitiated, a brand may look no more familiar than an Egyptian hieroglyph; but with a little practice, a pattern soon emerges.

It is a testament to the breadth and scope of J.R.R.Tolkien's vision and imagination that the Elvish alphabet should be popular as a source of tattoo motifs, because Elvish is an invented language, spoken by the race of Elves in *The Lord of the Rings*. A tattoo design using the Elvish alphabet symbolizes a belief in the magical, the power of imagination and fantasy, and is a desire to aspire to all the best qualities embodied in the Elven Race.

GREEK

αγάπη	*LOVE*	γενναιότητα	*BRAVERY*
πολεμιστής	*WARRIOR*	σεβασμός	*RESPECT*
εξουσία	*POWER*	σοφία	*WISDOM*
αντρία	*COURAGE*	ευτυχία	*HAPPINESS*
ελευθερία	*FREEDOM*	αρμονία	*HARMONY*

KANJI

	DRAGON		*STRENGTH*
	ETERNITY		*TIGER*
	HEAVEN		*TRANQUILITY*
	PEACE		*TRUTH*
	SPIRIT		*SUN*

ARABIC

حُب	*LOVE*	جميلة	*BEAUTIFUL*
ملك	*KING*	محظوظة	*LUCKY*
ملكة	*QUEEN*	شرير	*WICKED*
للتغلب على	*TO OVERCOME*	رغبة	*DESIRE*
حرية	*FREEDOM*	غزل	*FLIRT*

CHINESE

愛	*LOVE*	勇敢	*BRAVERY*
武	*WARRIOR*	尊敬	*RESPECT*
權	*POWER*	智	*WISDOM*
勇氣	*COURAGE*	快樂	*HAPPINESS*
自由	*FREEDOM*	和諧	*HARMONY*

SANSKRIT

བ ཙང ཨ	*PURITY*	སྱ ལན འང ས པ	*NIRVANA*	
ལ ས	*KARMA*	འདོང པ	*DESIRE*	
ནི བ	*PEACEFUL*	ཤེ ས རབ	*WISDOM*	
ར གེ བ	*VIRTUE*	ཨེ ར འོ	*DELIGHTFUL*	
ཐ ར བ	*FREEDOM*	དོན ཨ བའེ ན པ	*ULTIMATE TRUTH*	

ELVISH

ᘓᘈ	*LOVE*	ᘖᘌᘜ	*BRAVERY*	
ᘗᘊᘘ	*WARRIOR*	ᘋᘐᘂᘝ	*RESPECT*	
ᘘᘛᘞ	*POWER*	ᘑᘝᘟᘟ	*WISDOM*	
ᘆᘔᘜ	*COURAGE*	ᘖᘀᘚ᠒	*HAPPINESS*	
ᘔᘖᘟᘟ	*FREEDOM*	ᘖᘆᘟᘟ	*HARMONY*	

MONOGRAMS & BRANDS

 ROLLING W

ROCKING R

SUNSHINE

FLYING H

BULL HEAD

AMBIGRAMS

ANNA

DAVID

MARIA

CONTRIBUTORS

VINCE HEMINGSON
The author is a well-known writer and historian of tattoo lore, and was the co-writer, producer and host of the critically acclaimed documentary film *The Vanishing Tattoo*. His website is widely acknowledged as the largest and most comprehensive website devoted to tattoo-related material on the Internet (www.vanishingtattoo.com).

BOB BAXTER
The foreword is written by Bob Baxter, Editor-in-Chief of *Skin&Ink* magazine, published in the USA. The magazine is committed to presenting the fine art side of the tattoo industry, and the history and cultural anthropology of tattooing around the world (www.skinink.com).

CHUCK ELDRIDGE
Supplier of historical images, Chuck Eldridge is one of the world's pre-eminent tattoo archivists and historians working today. The Tattoo Archive serves to protect the Paul Rodgers Collection, one of the most important collections of tattooing memorabilia in existence today (www.tattooarchive.com).

J. D. CROWE
Illustrator J. D. Crowe is the number one supplier of tattoo images to tattoo parlors in the world. J. D. has published and re-published numerous collections of his tattoo designs under the name Official Tattoo Brand (www.tattoo-art.com).

STOTKER TATTOOS
Consultant and supplier of images, Mirek vel Stotker began tattooing in 1992 and opened Stotker Tattoo studio in north London in July 2008. Stotker has won awards from tattoo conventions all over the world, including Liechtenstein, Barcelona, Berlin, Vienna, and Tahiti (www.stotkertattoo.com).

IMAGE CREDITS

All other images are the copyright of Quintet Publishing Ltd. While every effort has been made to credit contributors, Quintet Publishing would like to apologize should there have been any omissions or errors— and would be pleased to make the appropriate correction for future editions of the book.

A = above, *B* = below, *L* = left, *R* = right, *C* = center *T* = top, *F* = far

J. D. CROWE Quintet Publishing wishes to thank J. D. Crowe for the following illustrations, © Official Tattoo Brand, appearing on pages: 14 *T*; 83 *T-L, T-R, C-L, C-R, B-L, B-R*; 84 *A-L*; 85 *B*; 86 *B-L, B-C, B-R*; 87 *B-L, B-C, B-R*; 89; 90 *B-L, B-R*; 91 *B-L, C-L, C-R, R*; 92 *B-L, B-C-L, B-C-R, B-R*; 93 *A-L, A-C, A-R, B*; 94 *B-L*; 95 *B-L, B-R*; 97; 99 *B-L, B-R*; 100 *B-L, B-C, B-R*; 101 *B-L, B-C, B-R*; 103; 104 *B-L, B-C, B-R*; 105 *A-C, A-R, B-L, B-R*; 106 *B-T, B-C, B*; 107 *B-L, B-C, B-R*; 108 *B-C, B-R*; 109 *B-L, B-C, B-R*; 110 *B-L, B-R*; 112 *B-L, B-C, B-R*;

113 *B-L, B-C, B-R*; 114 *B-L, B-C, B-R*; 115 *B-L, B-C, B-R*; 116 *B-L, B-R*; 117 *B-L, B-R*; 119 *L, C, R*; 121; 123; 124 *B-L, B-R*; 125 *B-L, B-R*; 126 *B-L, B-R*; 127 *B-L, B-R*; 129; 130 *B-L, B-C, B-R*; 131 *B-L, B-C, B-R*; 132 *B-L, B-R*; 133 *A-L, A-R, B*; 134 *B-L, B-C, B-R*; 135 *B-L, B-C*; 136 *B-L, B-R*; 138 *B-R*; 139 *B-R*; 141; 142 *B-L, B-C*; 143 *B-L, B-C, B-R*; 145 *T, B*; 146 *B-L*; 147 *B-R*; 155; 156; 157; 159; 161 *C-L, C-R*; 163; 165 *T-L, C-L*; 169; 171; 172 *B-C, B-R*; 173 *B-R*; 174 *B-C, B-R*; 175 *B-L, B-C, B-R*; 176 *B-L, B-C, B-R*; 182 *B-L, B-C, B-R*; 187 *T-L, B*; 189 *T, B*; 191; 193; 197; 198 *T*, 199 *B*; 200 *B-L, B-R*; 201 *B-L, B-R*; 202 *B-L, B-R*; 203 *B-L, B-R*; 205 *C-B, B*; 206; 207 *B-L, B-C, B-R*; 208 *B-L, B-C, B-R*; 209 *B-L, B-C, B-R*; 211; 212 *B-L, B-R*; 213 *B-L, B-R*. **SHUTTERSTOCK** 13; 14 *B*; 21 *T*, 23 *T, C-L, B-R*; 25; 26; 29; 30; 31; 32; 50; 51; 61; 63; 73; 79; 80; 82; 84 *T-L, T-R*; 86 *T-L, T-R*; 87 *T-L, T-C, T-R*; 88 *T-L*; 90 *T-L, T-C, T-R*; 91 *T-C*; 92 *T-C, T-R*, 93 *T-L*; 94 *T-L, T-C, T-R, B-R*; 95 *T-L, T-C*; 96 *T-L*; 98 *T-L, T-C, T-R*; 99 *A-C, B-C*; 100 *T-L, T-R*; 101 *T-L, T-C*; 104 *T-L, T-C, T-R*; 105 *T-L, T-C*; 105 *T-L, T-C, A-L, B-C*; 106 *T-L, T-C*; 107 *T-L*; 108 *T-L, T-R*; 109 *T-C*; 110 *T-R*; 111 *T-L, T-R, B-L, B-C, B-R*; 112 *T-L, T-C*; 113 *T-L, T-C, T-R*; 114 *T-L, T-C*; 115 *T-L, T-C*; 116 *T-L, T-C, T-R*; 117 *T-L, T-C*; 118 *L, R*; 120 *T-L, T-C*; 124 *T-L, T-C, T-R*; 126 *T-L, T-C, T-R*; 127 *T-L, T-C, T-R*; 128; 130 *T-L, T-R*; 131 *T-L, T-R*; 133 *T-L, T-C*; 134 *T-C, T-R*; 135 *B-R*; 136 *T-L, T-C, T-R*; 137 *T-R*, 138 *T-L, T-C, T-R, B-L*; 139 *T-R*; 140 *R*; 142 *T-L*; 143 *T-L, T-C, T-R*; 144 *C-L, R*; 145 *C*; 146 *T-L, T-C, T-R*; 147 *T-L, T-C, T-R*; 148, 149; 150; 151; 152; 153; 154 *T-L, T-R*, 158; 161 *B-L*; 162 *T-L*; 164; 165 *B-R*; 166 *T-R*; 167 *T-L, T-C, T-R*; 168 *L, C-L, R*; 170; 172 *T-C, T-R*; 173 *T-L, T-C, T-R*; 174 *T-L, T-R*; 175 *T-L, T-C, T-R*; 177 *T-C*; 179; 180 *T-R*; 181 *B-R*; 182 *T-C, T-R*; 183; 184 *T-L, T-C, T-R*; 185 *T-R*; 188 *C-R*; 189 *C*; 190 *R*; 192; 194 *T-L, T-R*; 195 *T-L, T-R*; 196 *R*; 198 *B*; 199 *T*; 200 *T-L, T-C, T-R*; 201 *T-L, T-C, T-R*; 202 *T-L, T-C, T-R*; 203 *T-L, T-C-L*; 209 *T-L, T-R*; 210; 212 *T-L, T-C, T-R*. **CORBIS** 15 Alvaro Lopez/Corbis; 53 © Bettmann/CORBIS; 56 © Markus Cuff/CORBIS; 59 © Photo Collection Alexander Alland, Sr./CORBIS; 77 © Bettmann/CORBIS; 135 *T-L* © Shaul Schwarz/CORBIS; 176 *T-R* © Claus Fisker/epa/Corbis; 213 *T-R*. **ALAMY** 37 © Jon Arnold Images Ltd/Alamy; 47 © Picture Contact/Alamy; 48 © INTERFOTO Pressebildagentur/Alamy; 54 © INTERFOTO Pressebildagentur/Alamy; 65 *B*; 67 © dbimages/Alamy; 72 © IMAGEPAST/Alamy; 75 © Trinity Mirror/Mirrorpix/Alamy; 185 *T-C* © Suzanne Long/Alamy. **WOW TATTOOS** 219 Ambigram tattoo designs by Mark Palmer, owner of WowTattoos.com and the world's leading Ambigram tattoo artist. **ISTOCK** 2; 21 *B*; 23 *A-L, L, B-L, T-R, A-R, R, B-R*; 65 *A*; 88 *T-C, T-R*; 91 *T-L, T-R*; 92 *T-L*; 93 *T-C-L, T-C-R, T-R*; 95 *T-R*; 96 *T-C, T-R*; 99 *T-L, T-C, T-R*; 100 *T-C*; 101 *T-R*; 102; 106 *T-R*; 107 *T-C, T-R*; 108 *T-C*; 109 *T-L, T-R*; 110 *T-L, T-C*; 111 *T-C*; 112 *T-R*; 114 *T-R*; 115 *T-R*; 117 *T-R*; 118 *C*; 120 *T-R*; 122; 125 *T-L, T-C, T-R*; 132 *T-L, T-C, T-R*; 133 *T-R*; 137 *T-L, T-C*; 139 *T-L, T-C*; 140 *L*; 142 *T-C*; 154 *T-C*; 160; 162 *T-C, T-R*; 166 *T-L, T-C*; 168 *C-R*; 172 *T-L*; 174 *T-R*; 176 *T-L, T-C*; 177 *T-L, T-R*; 178; 180 *T-L*; 181 *T-R*; 186 *F-L, C-L, R*; 188 *L*; 190 *L, C*; 196 *L, C*; 203 *T-R*; 204; 207 *T-L, T-C, T-R*; 208 *T-L, T-C, T-R*; 209 *C-L*; 213 *T-L, T-C*. **C. W. ELDRIDGE, TATTOO ARCHIVE** Photos Courtesy of Paul Rogers Tattoo Research Center: 12; 35; 36; 59; 62; 72. **KOBAL COLLECTION** 55. **STOKER TATTOOS:** 105 *T-R*; 131 *T-C*; 134 *T-L*; 135 *T-C, T-R*; 140 *C*; 142 *T-R*; 144 *L, C-R*; 180 *T-C-L, T-C-R*; 182 *T-R*; 186 *C-R*; 203 *T-C-R*; 209 *C-R*. **GETTY IMAGES** 10 Hulton Archive/Getty Images; 11 Chris Rainier/Getty Images; 17 3D4Medical.com; 44 Hulton Archive/Getty Images; 71 Mansell; 181 *T-L* Per-Anders Pettersson; 185 *T-L* Chris Rainier/Getty Images. **VINCE HEMINGSON** 9; 38; 40; 41.

ACKNOWLEDGMENTS

Undertakings like the *Tattoo Design Directory* rarely leap fully formed from the imagination. They come together in fits and starts, and with much help, guidance and kind assistance from many quarters. It is no exaggeration to say that my life changed forever the day I walked into West Coast Tattoo in the summer of 1996 in Vancouver, British Columbia, Canada and met Thomas Lockhart. A world-renowned tattoo artist, fellow bon vivant, and adventurer, Tom regaled me with riveting tales of tribal tattooing while inking my own epidermis. More importantly, he gave me unfettered access to his extraordinary library and collection of tattoo memorabilia collected from every corner of the globe. It was the start of my education in all things tattoo. Meeting Tom was the genesis of both a documentary film on traditional tribal tattooing and the Vanishing Tattoo web site, which took on a life of its own. None of the aforementioned could have been accomplished without the encouragement and boundless passion of my good friend and colleague, the late Stacy Kirk, the stalwart support of my writing partner and brother-in-arms, PJ Reece, fellow producer Jack Silberman, crew members, Earl Kingi and Errol Samuelson and the kind folks at Natural History New Zealand (NHNZ), Neil Harraway in particular, Don Ramsden and Warren Hill, and my web guru, Doug Cook. Along my tattoo path I encountered numerous tattoo artists, fellow tattoo enthusiasts, scholars and cultural anthropologists who shared with me their stories, knowledge and expertise and even more importantly, encouraged me on my quest; Lars Krutak, Lyle Tuttle, Chuck Eldridge, Steve Gilbert, Bob Baxter and Bernard Clark, Eddie and Simon David, David and Alice Umpie, the unforgettable Aki Basai, Yoshito Nakano—Horiyoshi III, Tavana Salmon, Laurie Nichols and Gordon Toi, Petelo Suluape, Keone Nunes, David Seton, Patricia Steur, Pym Mahon, Pat Fish, Marisa DiMattia, Naomi MacPherson, Rachel Black, and Margo Chapman Kendall, just to name a few. On the home front, my tenuous grasp of modern technology was aided and abetted by a group of friends who kept my cyber lifeline connected at all times; Richard Pitt, John Batyka, Patrick Gross, and Justin Callison. Along the way my parents, although a little bewildered at my fascination with body art, gave their blessings as I followed my bliss. Thanks, Mom. Miss you, Dad. My editor at Quintet, Asha Savjani, deserves special credit for her heroic ability both to shepherd my writing and put up with my many and often vociferous demands. I am eternally grateful for Asha's patience, tolerance, grace, and understanding during this process. If I have overlooked or missed anyone, it is purely an oversight on my part. What knowledge I have imparted, I owe to others; the mistakes are surely my own. A special acknowledgment to all my running buddies over the many years of training for marathons who have tolerated my long-winded stories along the way... Vincent Errol Hemingson.